The
Watercolour
Flower Artist's
Bible

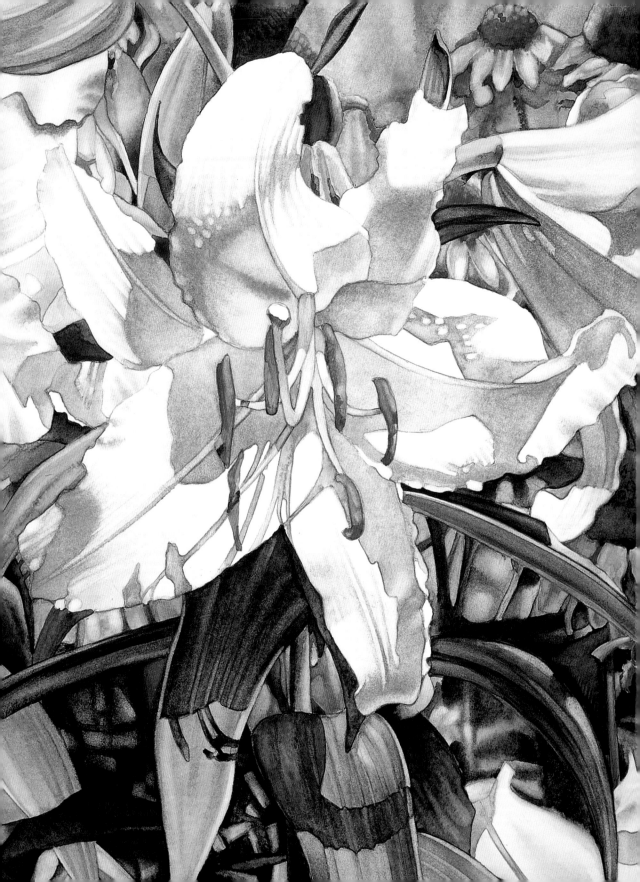

The
Watercolour
Flower Artist's
Bible

An essential reference for the practising artist

edited by
Claire Waite Brown

Search Press

A QUARTO BOOK

Copyright © 2007 Quarto Publishing plc
This edition published in 2016 by
Search Press Ltd
Wellwood
North Farm Rd
Tunbridge Wells
Kent TN2 3DR

ISBN: 978-1-78221-397-0

Conceived, designed and produced by
Quarto Publishing plc
The Old Brewery
6 Blundell Street
London N7 9BH
www.quartoknows.com

QUAR.FPBI

Project Editor: Donna Gregory
Art Editor and Designer: Jill Mumford
Picture Researcher: Claudia Tate
Assistant Art Director: Caroline Guest
Managing Art Editor: Anna Plucinska

Art Director: Moira Clinch
Publisher: Paul Carslake

Manufactured by Modern Age Repro House Ltd,
Hong Kong.
Printed by Toppan Leefung Printing Ltd, China.

Picture credits on page 4: *Nancy Meadows Taylor*
Casablanca. Opposite, from left to right: *Tracy Hall*
Aquilegia, *Jana Bouc* Matalija Poppy, *Tracy Hall*
Passion flower.

Contents

Introduction

▲ Learn about light and shadow.

Anyone who has drawn or painted flowers will have discovered how challenging it is to capture their colour and beauty. A successful flower painting should depict the essence of the flower – its shape, texture and colour – as well as intangible qualities such as freshness and scent. Some try to pin down the spirit of a flower in formal botanical paintings, while others aim to express ephemeral spirit through more expressionistic line and colour.

Watercolour is the perfect choice of medium for rendering the beauty and fragility of flowers and their vivid or delicate colours, and the aim of this book is to show you how to paint a wide variety of flowers in detail, using a range of different watercolour techniques and paint mixes.

The opening section of the book looks at the tools and materials required for flower painting and illustrates the basic watercolour techniques.

You will also find here some special techniques that will help you to capture various vital characteristics of flowers and plants.

The next section categorizes flowers into a series of basic shapes, with a description of each flower type and drawings and examples examining principles of perspective and the patterns of light and shadow comprising the three-dimensional form.

The directory of flowers is an invaluable source of inspiration that shows you how to paint a vast collection of flowers and some leaves and berries, employing a wide variety of techniques. Each flower is painted as a sequence of steps, followed by the completed painting, with captions that describe the colours used, the colour mixes required, and the techniques involved. Watercolour flower painting takes practice and

▲ Discover how to break flowers down into simple shapes.

the flowers themselves are not always easy to portray, because the intricate shapes can appear bewildering until you learn to break them down to their simplest form.

Within the directory section you will also find examples of the work of other artists, since looking at their work can provide invaluable inspiration for the aspiring flower artist.

One of the great attractions of flower painting is that it gives you so much freedom and this book will help you

◄ Experiment with colour and brushstrokes.

to see some of the possibilities. Developing skills is important, but what matters even more is that you take pleasure in what you do, and with *The Watercolour Flower Artist's Bible* you will soon find yourself painting flowers in watercolour with confidence and enjoyment.

▼ Be inspired by the work of other artists.

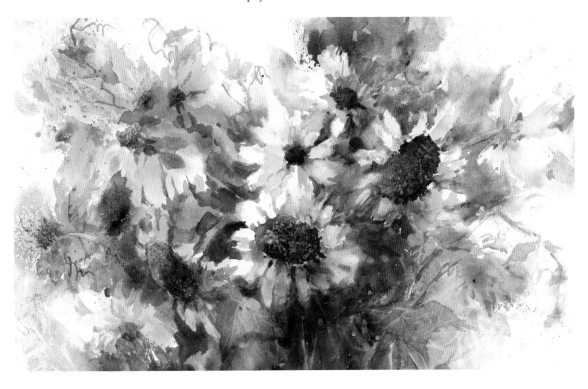

Chapter One
Materials and techniques

Thankfully, when it comes to painting beautiful flowers in watercolour you don't need a vast quantity of materials and equipment. In the following pages you will find information and advice to help you choose what you do need. This section also focuses on the methods of work that are most useful to the flower artist, from simple washes to composing the final piece.

About paints

The delicacy and translucency of watercolour makes it an ideal medium for flower painting. The paint itself can be bought as liquid, ready-to-use colour in tubes, or in square pans of dry colour that needs mixing with water. It is also made in two different qualities, usually referred to as artists' or students' colours. The latter are the cheaper option, but they contain less pure pigment than artists' quality paints, which means that the colours are not as intense. They are also usually less transparent, more grainy and not as reliably lightfast as the more expensive artists' varieties. Therefore, it is advisable to buy the more expensive paints, because for flower colours in particular you do not want to struggle with muddy or grainy pigments.

Useful mediums

Since water is the primary medium for watercolour work, you do not strictly need anything else. However, you may, on occasion, choose to use a few drops of ox gall (**3**) in the water to help the paint flow smoothly, or mix gum arabic (**2**) with watercolour on the palette to give the paint extra body without affecting its transparency. Masking fluid (**1**) is a medium that can be painted onto the paper in order to reserve fine highlights, such as on stamens and anthers.

Intensity of colour

Watercolour dries much lighter than it appears when wet, so it is a good idea to judge the intensity of the colours you choose by testing them on spare paper.

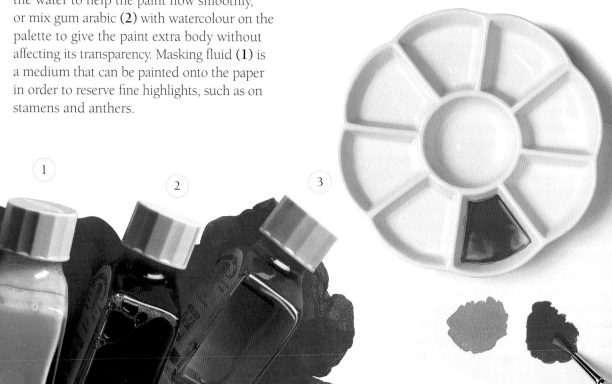

1

2

3

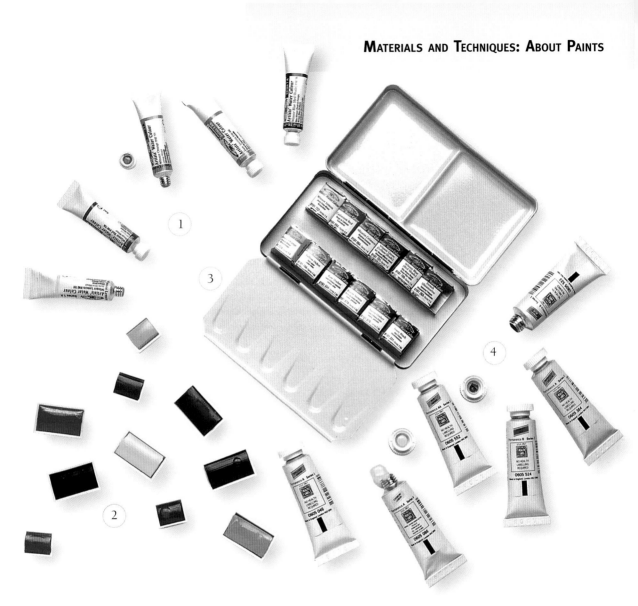

1 Tubes of watercolour

Tubes of ready-to-use transparent watercolour are especially practical for large-scale work. The paint in this format is often easier to keep clean than paint in pans and, provided the tops are replaced after each use, will last a long time.

2 Pans and half-pans of watercolour

Pans and half-pans of dry watercolour are useful if you only use small amounts of paint at a time. Many artists find pans more convenient than tubes because they fit within a paintbox and can be carried around easily for outdoor work.

3 Pans of watercolour in a paintbox

Paintboxes for pans have central recesses to hold the pans and a fold-out lid and mixing tray that you can use to mix colours.

4 Gouache

Gouache is an opaque version of watercolour and the two paints can be used together in the same way. Artists often use a little white gouache to reclaim highlights in a watercolour painting, or use coloured gouache to vary the consistency of paint in the same picture, contrasting transparent and opaque areas.

About paper

Watercolour paper loves water and will remain undamaged from a soaking. It is also strong enough not to rip when stretched, and delicate enough to produce the most beautiful effects. Watercolour papers are available in varying surface textures – hot-pressed, cold-pressed and rough – and thicknesses. The thicknesses are measured in weight, expressed as grams per square metre (gsm) or pounds per ream (lb), and range from 600 gsm (300 lb) – almost like board – to about 120 gsm (60 lb), which is very flimsy. It is a good idea to try out various sorts of paper to discover which best suits your style and expectations. You will find that the texture and absorbency of different papers affect the way the paint behaves, but once you have found a paper you like, stick with it, because there can be considerable variations from one manufacturer to another.

Stretching paper

Any paper lighter than 300 gsm (150 lb) needs to be stretched before use, unless you are working on a very small scale and using the paint quite dry, otherwise the water will cause it to buckle. If you work with very wet paint, you may need to stretch 300 gsm (150 lb) paper. In order to stretch a sheet of paper you will need gummed brown-paper tape and a drawing or plywood board that will not warp.

1. Wet the paper on both sides, either by immersing it in a bath and shaking off the surplus or using a sponge. Wet the wrong side of the paper first, then turn the sheet over on the board and wet the right side.

2. Cut a strip of gummed brown-paper tape to the length of the long side of the paper and dampen it by passing it over a wet sponge.

3. Stick the tape down onto the paper and the board and use the sponge to smooth it out and ensure it adheres properly. Repeat for the remaining three sides. Leave the paper to dry naturally.

The effects of paper texture

Hot-pressed papers

Hot-pressed (HP) paper is made smooth by passing it through heated rollers after it is made. It is often used for botanical painting, and less often by beginners.

Cold-pressed papers

These papers are pressed between unheated rollers lined with felt mats that impart a texture, or 'tooth' to the paper's surface. Also referred to as 'not' surface, because it has not been hot pressed, this is the most commonly used paper, because it has sufficient texture to hold the paint but is smooth enough to enable you to paint fine detail.

Rough papers

Rough papers are not pressed at all, and each brand has a characteristic rough surface. This rough surface acts as a moderating influence and helps to control the flow of pigment.

The smooth surface of hot-pressed paper causes the paint to puddle, because there is not enough texture to keep it in place, a characteristic that some artists like to exploit.

Cold-pressed paper has just enough texture to drag the paint off the brush to create a wide variety of effects.

The grain of rough paper breaks up brushmarks, creating broken lines and areas of colour. Used fairly dry, pigment can be dragged across the surface to produce many textures.

Brushes and equipment

Apart from the paints themselves, the most vital pieces of equipment are your brushes, and you should choose wisely and look after them well. Round brushes are the most useful for flower painting and are made in a range of sizes, from number 0 (tiny) to 12 or 14. You will not need a huge selection because a good brush that comes to a fine point can be used for both detailed and broad work.

You will also need waterpots, and may find that extra palettes come in useful. Any other additional items you can probably find around the home.

Brush care and maintenance

- Always clean out your brush at the end of each painting session. Keeping brushes scrupulously clean will extend their lives.

- To clean a sable brush, roll it gently between finger and thumb using soap, then rub gently on the palm of your hand, right to the ferrule, and rinse well.

- Make sure you rinse out the colour in the bristles within the ferrule.

- After washing, shape the bristles back into shape before leaving to dry.

- Do not leave brushes standing on their heads, because this will cause them to go out of shape.

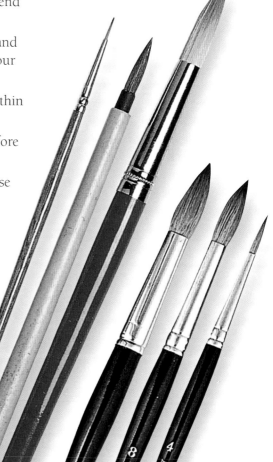

Round brushes
Round brushes are extremely versatile, enabling you to make a variety of different brushmarks and to paint linear detail. The best brushes are Kolinsky sable, which are expensive, but last a lifetime if looked after. The less expensive alternatives range from sable and synthetic mixes to wholly synthetic varieties. When buying brushes, make sure that the bristles come to a fine point without the hairs splaying out.

Kitchen towel
Kitchen towel is useful for general cleaning up, and can also be used for various lifting-out techniques.

Sponge
A small natural sponge forms part of most watercolourists' kits. This can be used for washing off paint when a mistake has been made, or for softening edges, laying washes, and lifting-out techniques.

Waterpots
Waterpots can take the form of a recycled jamjar or yogurt pot, or, for those working outdoors, a nonspill pot.

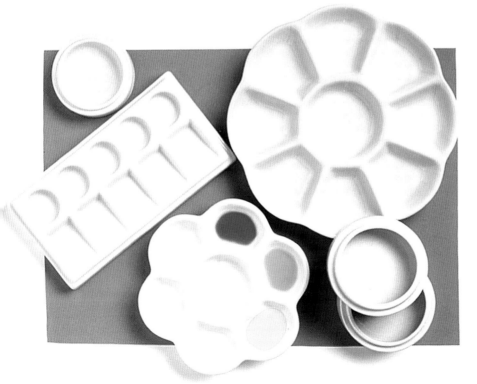

Palettes
Watercolour paintboxes containing pans of colour incorporate their own palettes, but these do not always provide enough space for mixing, so you may need an auxiliary palette. If you use tubes of paint, you will need a palette with recesses to squeeze the colours into and shallow 'wells' to keep the mixed colours separate. There is a wide choice of such palettes, made in china and plastic.

Choosing and using colour

When considering the effects of the colours you use, it is helpful to know something about their properties and characteristics.

This basic knowledge will allow you to appreciate and predict what happens when watercolours mix.

The colour wheel

The colour wheel is a useful diagrammatic arrangement of colours that illustrates some basic aspects of colour theory. The colour wheel, which is basically a simplified version of the spectrum, bent into a circle, shows the three primary colours – red, yellow and blue – separated by the secondaries, orange, green, and purple. You can see from the colour wheel that the colours that sit next to each other tend to harmonize, while the ones on opposite sides of the wheel, called complementaries, are sharply contrasting.

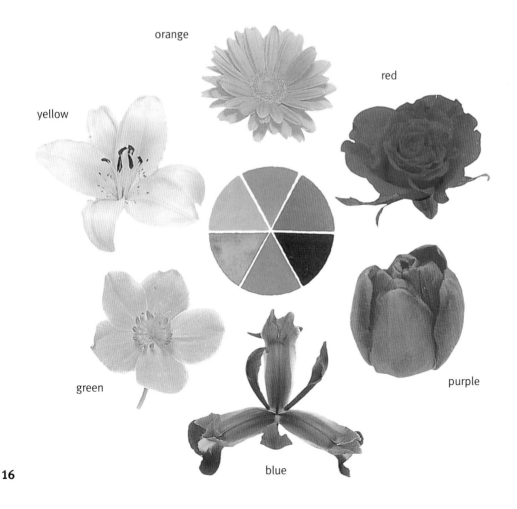

orange

red

yellow

green

blue

purple

Primary and secondary colours

Red, yellow and blue are the primary colours, which means they cannot be mixed from any other colours. Mixtures of two primary colours make secondary colours. There are many variations in the secondary ranges, depending on which reds, yellows and blues are used. Trial and error will teach you which primary colours to mix to achieve the flower or leaf colour you need, and the colour can be lightened by adding water.

Blue and yellow make green.

Yellow and red make orange.

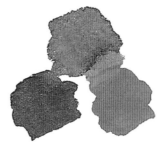

Blue and red make purple.

Tertiary colours

A mix of three primary colours, or one primary and a secondary, gives a tertiary colour. Some of the tertiaries are the browns and grays described as neutrals, but they can produce more vivid shades. You will find sympathetic browns for stems or deep shadows often arrive without much adjustment if you mix them from the colours already in use.

Complementary colours

Complementary colours fall opposite one another on the colour wheel. When placed next to each other the colours intensify one another. However, when they are overlaid or blended together they subdue or neutralize each other's intensity. A good way to show shadows on flowers is to add the complementary colour.

Use green to create a realistic shadow on a red flower.

Red, blue and yellow make brown.

Mixing colours

Learning to mix colours is a vital skill, which is mainly acquired through experiment. Until you are sure of your ability, try out mixtures before committing yourself.

A vital point to remember is that mixed colours are always darker, or less pure, than the original paints used to make them.

If you want a vivid mixture, avoid using more than two colours, otherwise you may muddy the result. Watercolours used straight from the pan or tube are always brighter than mixtures and even when only two colours are mixed the brilliance of both is slightly reduced.

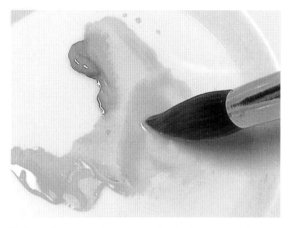

Watercolours can be mixed physically on a plate or in a palette.

Watercolours will mix optically if washes are overlaid, one over the other.

Colour changes

Watercolours are semitransparent, meaning that light colours laid over dark ones become darker, and traditional practice is to begin a painting with the lightest tones and build up gradually toward the darker ones using successive washes or brushstrokes. The first colour and tone you put down will be changed by the colours laid over it. If a pale yellow is covered with blue, the colour changes to become green, and the tone darkens because there are now two layers of paint. By the same token, a colour that is too pale can be darkened by applying a second wash of the same colour, or a slightly darkened version of it.

Cadmium red overlaid with alizarin crimson.

Cadmium red overlaid with cadmium yellow.

Cadmium red overlaid with raw sienna.

A flower painter's palette

The brilliant colours of flowers may tempt you to buy a huge range of watercolour paints, but it is better to start with a small number that can be mixed to great effect. Pigments often darken when dry, so avoid any that are muddy or grainy, to maintain clear, bright flower colours. This palette features all the colours used in the directory section of this book.

*Those that are essential have been marked with an asterisk.

*Lemon yellow

Indian yellow

*Cadmium yellow

Naples yellow

Brown-pink

*Quinacridone gold

Raw sienna

Burnt sienna

Raw umber

Burnt umber

Green-gold

*Cadmium orange

Chrome orange

Cadmium red

Brown madder

Rose doré

Bright red

*Alizarin crimson

Permanent rose

Cobalt violet

*Dioxazine violet

*Permanent magenta

Permanent mauve

*Cobalt blue

*Ultramarine

*Phthalo blue

*Cerulean blue

Indigo

Cobalt green

*Phthalo green

*Sap green

Olive green

19

Washes

Washes may cover a large or small area, and are usually the starting point for most watercolour paintings. The term 'wash' implies a relatively broad area of paint being applied flatly, but it also describes each brushstroke of fluid paint, however small it may be, and washes are often graded in tone or contain more than one colour.

Flat wash

The flat wash is the easiest method of applying watercolour to paper. The paper can be horizontal or tipped at a slight angle, so that the brushstrokes flow into each other but do not dribble down the paper.

1. Load a brush with dilute watercolour and, starting at the top of the area to be covered, sweep it across dry paper.

2. Keep dragging the brush across the area, reloading with paint as necessary. Overlap the previous wet colour a little, so that the new stroke blends perfectly with the old one. Do not overpaint an area while wet – this will result in an uneven wash.

Graded wash

A graded wash is one that varies in tone. For example, on a petal this usually means the wash becomes paler toward the bottom. The gradation is achieved by gradually adding water to the colour.

1. Start with a flat wash of colour. Dip the brush in clean water and paint the dilute colour below the still-wet previous area.

2. Add more water to the brush for each area of colour. Remember that each wash should only be one step lighter than the previous one, so take care not to dilute too quickly.

Graded shadow

A graded wash is used as the first step in suggesting the shadows on these delphinium florets. The light is coming from top left, so the mid-toned colour on the right is lightened to a cool, pale wash on the left.

Variegated wash

A variegated wash varies in colour, and the technique involves adding further colours to a still-wet flat wash or damp paper.

1. Start by painting the whole shape with a flat wash.

2. When the paint is nearly dry, apply the second, darker colour. The second pigment will diffuse easily into the damp surface, giving soft edges where the dark colour meets the lighter one.

3. Alternatively, wet the shape first with clean water, bearing in mind that the water will dilute the paint. Paint the colour up to the point where the second colour is to be used.

4. Paint the rest of the damp shape with the second colour, either going up to the first colour or overlapping it a little. Leave the colours to blend on the damp surface.

Wet-in-wet

The wet-in-wet technique involves applying each new colour without waiting for the earlier ones to dry, so that they run together with no hard edges or sharp transitions. When you drop a new colour into a still-wet wash, the weight of the water forces the first colour outwards, so the colours bleed into one another without actually mixing. The technique is only partially controllable, but is very enjoyable and challenging for precisely this reason. Make use of wet-in-wet methods at certain stages of a painting, or in specific areas. For example, you may begin by wetting the paper all over before laying the colours, or combine wet-in-wet with wet-on-dry work (see pages 26–27), dampening the paper only in selected areas. The paint will not flow onto dry paper, so you can control the edges of a wet-in-wet shape quite precisely, a technique often used for painting flower heads.

1. Start by dampening the paper thoroughly with a sponge. You may like to use slightly coloured water, as here, to provide a background tint.

2. Begin to brush in areas of colour, allowing them to spread and merge on the wet ground.

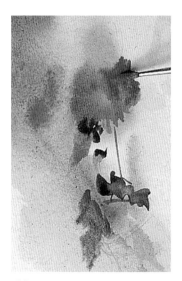

3. To achieve crisper edges, let the paper dry slightly before touching in the darker colours.

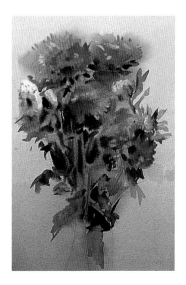

4. Continue to build up the painting using slightly thickened paint. Highlights cannot be reserved when working in this way, so use opaque white where necessary. Touches of soft definition give depth and form to the leaves and flower heads.

Dropping

Dropping colour into a wet wash can vary a flat tone and is a good way of adding texture to foliage or flower petals. Load a brush with watercolour and either touch the wet wash with the tip of the brush or allow droplets to fall off the bristles into the wash. Larger droplets are made by using more paint, and smaller ones by using less paint.

Petal effects

Strong paint placed next to an area of damp paint will into fan it. Merges like this are invaluable for capturing the subtlety of flowers.

Backruns

Although backruns are often considered a nuisance, they can also be encouraged and used to advantage. When you apply more colour to a wash before it is completely dry, the new paint will seep into the old, creating strangely shaped blotches or cauliflower shapes. This is especially true when you are working on smooth papers. The effects created are quite unlike anything achieved by conventional brushwork, and are often deliberately induced to suggest petals, flowers or foliage. You can also make dramatic backruns, as here, by dropping clean water into wet paint; the more water the larger the backrun.

Wet-on-dry

With this classic watercolour technique, paintings are built up from light to dark by laying successive washes over paint that has been allowed to dry. Wet-on-dry work leaves crisp, hard edges formed as each wash dries.

Within watercolour work, glazing is another term used to describe an aspect of wet-on-dry work. A glaze is simply a wash of colour laid over an earlier dried colour, either to amend it or to give it more depth.

Crisp edges

Crisp edges can be exploited by allowing the first wash to dry before applying the second colour. For example, here clearly defined leaf veins are painted wet-on-dry with a small brush.

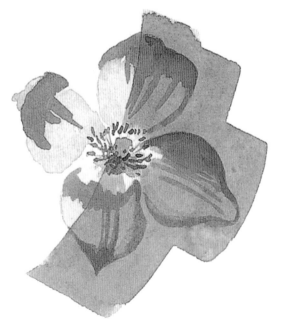

Glazing to unify colours

If the colours in a painting are not working as well together as you would like, they can be unified with an overall glaze. The dry pink and yellow here are too distinct from one another, but a glaze of permanent rose laid on top brings them together.

Glazing to enliven colours

If the dry colours look too dull, use a glaze to enliven them. Here the leaves, painted in two tones of a neutral green, are given sparkle with a glaze of phthalo green.

Glazing to subdue colours

Overbright colours can be subdued with a glaze. In this instance the background colours needed to be cooler to push them back in space, so a thin glaze of phthalo blue was laid over them.

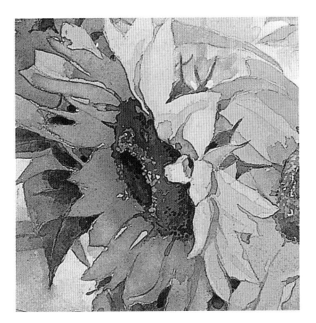

Glazing shadows

To create the shadow effect on this sunflower, the yellow of the petals has been glazed over with thin washes of violet.

Tutorial *Combining wet-in-wet and wet-on-dry*

The two best-known methods of working in watercolour – wet-in-wet and wet-on-dry – although regarded as separate techniques, are often combined in one painting. In this painting the artist works wet-in-wet on certain areas of the work, controlling the flow of paint so that it does not become unmanageable, and wet-on-dry to touch in the details and bring the painting together. The artist uses hot-pressed paper because the colours run into one another and form pools on the smooth surface, a tendency she likes to exploit.

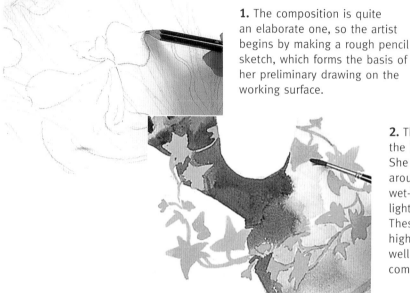

1. The composition is quite an elaborate one, so the artist begins by making a rough pencil sketch, which forms the basis of her preliminary drawing on the working surface.

2. The first paint applied is to the ivy decoration on the chair. She now paints Payne's grey around the leaves, working wet-in-wet so that puddles of light and dark paint are formed. These describe the irregular highlights on the chair very well. The rest of the chair is completed with Payne's grey.

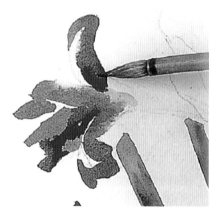

3. For the iris, ultramarine is merged wet-in-wet with dioxazine violet, the main flower colour.

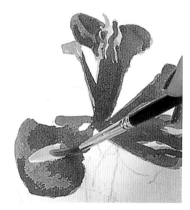

4. The flower heads are worked wet-in-wet, with successive colours dropped in with a well-loaded brush so that they form pools and tonal gradations. The yellow areas, on the other hand, need to be crisp and clear, so the paper is left to dry before adding these.

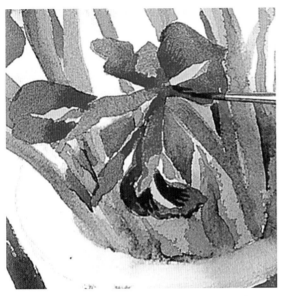

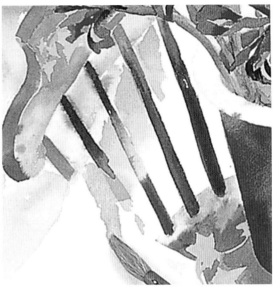

5. When the flowers and leaves are completed, they are allowed to dry. Final touches are added wet-on-dry, with the darkest flower tones picked up with violet straight from the tube.

6. The main colour used on the cloth behind the flowers has been chosen to contrast with the purple of the irises.

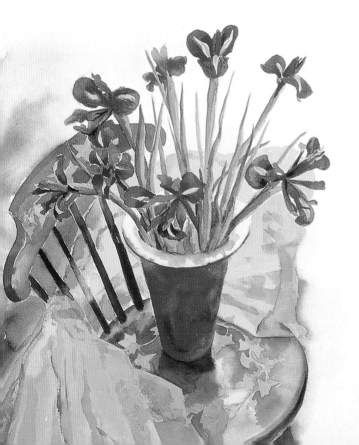

Rosalind Cuthbert
Irises

The completed painting has unity because the colours have been restricted, and similar ones have been repeated from one area to another to create a series of visual links. The grey background links with the chair, the shadows on the cloth pick up the leaf colours and the blue of the vase reappears on the irises.

Preliminary planning

Watercolours cannot be changed radically once work has begun, so some artists find it useful to sort out their ideas by making preliminary sketches or paintings. You may even choose to make an underdrawing directly onto the watercolour paper, although the drawn lines are likely to show through the paint in the paler areas.

Preliminary sketches

It is a useful exercise when looking at a subject to make preliminary pencil sketches of the shapes that catch your attention, concentrating on the main flower and leaf shapes and the fall of the shadows. This discipline will help you to familiarize yourself with the subject and organize a composition.

Brush sketch

Making a simple sketch with a brush will help you to decide what should be included in your final composition, and how to place the subject. Use a brush filled with the main colour, indicating the most important shapes. The painting can build from this point.

Underdrawing

An underdrawing is drawn directly onto the watercolour paper and covered with the watercolour work. When making an underdrawing keep the lines clear but as light as possible and avoid any shading. If you do need to erase any lines after painting, use a kneadable putty eraser and light pressure to avoid scuffing the surface of the paper and causing unsightly blotches.

Letting the drawing show through

Pencil lines are usually just a guide, to be erased eventually, though when the flower being depicted is pale against a white background, the pencil line can be a useful device. Make a preliminary drawing and paint over it. When dry, draw some pencil detail back to enhance the painting, using a soft pencil.

Tonal drawing

The brilliant colours of flowers may be what makes you want to paint them, but to give credibility to your work, you must also consider tonal values.

1. To help you to understand the tonal values of a painting – the lightness or darkness of colour – make a monochrome painting, using strong contrasts in the foreground and pale to middle tones in the background, to make them appear further back in space.

2. Paint the flowers again, this time with colours corresponding to the tones in the monochrome painting. Make the foreground stronger and warmer in colour, with more tonal contrast, and the background tone cooler and paler to suggest recession.

Hard and soft edges

The quality of edge you require is determined by whether you work into wet or dry paper. You may not want to use the same technique in every area of the painting, since a mix of hard and soft edges gives a painting more variety and is very effective at describing your subject. A carefully controlled use of the hard–soft contrast, with the paint blended in places and allowed to form edges in others, can be used to bring life to your flower paintings.

1. To illustrate the effect that wet paper has on your edge quality, brush a patch of colour onto dry paper.

2. Brush clean water next to the patch of colour, but not right up to the colour.

3. Before the paint or the water dries, brush more water along the side of the patch of colour, joining it to the area brushed with water. The colour flows into the water to produce a soft edge to one side of the new strip of colour. The edge of the patch that met dry paper is sharply defined.

4. When dry, the swathe of colour has a soft-focus edge on one side and a crisp edge on the other.

Softening edges

You can also use one of two techniques to soften edges after a flower
or leaf has been painted.

While the paint is still wet you can wipe
across the edges to be softened using some
clean tissue.

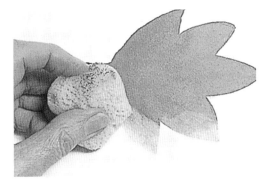

If the paint has dried, dampen a sponge
and wipe the edge to coax the paint off
the paper. Use a tissue to blot away any
paint that escapes the edges.

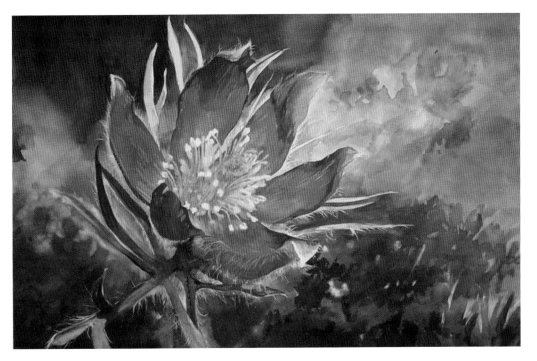

Karen Vernon *Pulsatilla*

In this painting, the artist uses a clever mixture of hard and soft edges to lead the eye to
the focal point – the glowing golden centre of the flower.

Tutorial *Combining hard and soft edges*

In this painting of tulips, the artist works on dampened paper so that colours run into one another, but she controls the flow of paint carefully so that the edge of each shape is crisp and clear, and there are no unwanted blobs or runs. The artist works on hot-pressed paper that encourages the paint to flow.

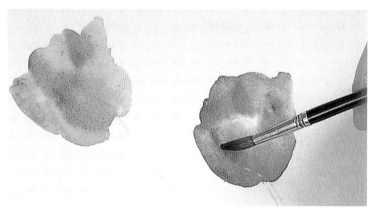 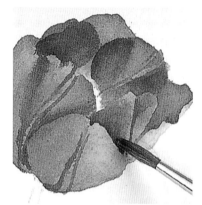

1. A loose drawing of the main shapes is kept broad and unfussy. Paint will not flow over from wet to dry paper, so the paper is dampened in the area of each flower head, within the boundaries of the drawn lines. Diluted permanent rose is then laid down, followed by darker magenta.

2. The paper is allowed to dry a little, but is still not fully dry, so that this darker colour spreads out slightly to give a soft look to the flower.

3. The paper is now almost fully dry in this area, and the artist is able to build up crisper definition, using a brush well loaded with strong colour.

4. The stem and leaves are painted in, and, when the pale green of the main mass of leaves is almost dry, a rich darker green is added in distinct, positive shapes that emphasize the curl of the leaves. Notice how all the edges are slightly softened and blurred because the paper has not been allowed to dry fully.

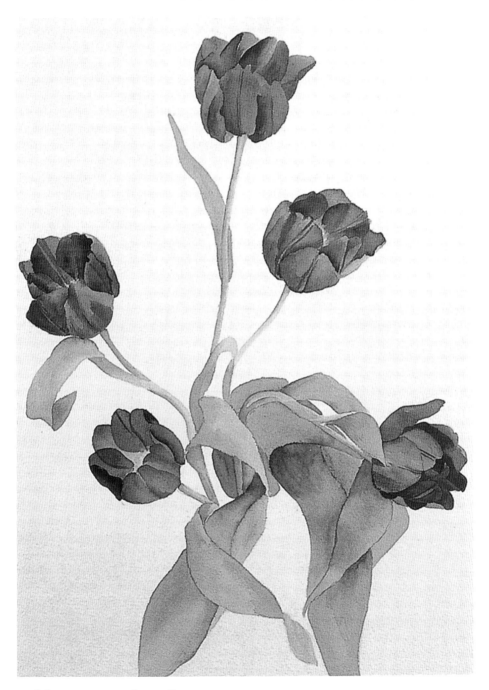

Libby Carreck *Tulips*

The strength of the completed painting lies in the artist's experience of watercolour and her skill in handling it. The brushstrokes are clear and decisive and nowhere has the paint been overworked or forced.

Controlling paint flow

Colours in nature are seldom perfectly flat and uniform, and it is often necessary to lay a wash that shifts in tone from dark to light or one that contains two or more colours.

You may find a sponge gives better results than a brush, as it is easier to control the amount of water you use – thinner paint will mix more freely and be harder to control.

Tilting the paper

The angle at which you position your paper can be adjusted to vary the effect made by the flow of paint. Tilting the board at an angle allows the paint to flow down in the direction of the tilt, creating a smooth shift in tone.

1. Tilt the board so that the edge nearest you is lower than the edge farthest from you. Paint the shape with a fully loaded brush of the first colour, then immediately tip in the second, darker colour.

2. The first colour flows gently downwards and merges with the second colour, creating a very soft, hazy effect.

Keeping the paper flat

When working wet-in-wet you can create an amorphous area of tone by keeping the paper flat, so that the colours flow into one another but do not run down the paper.

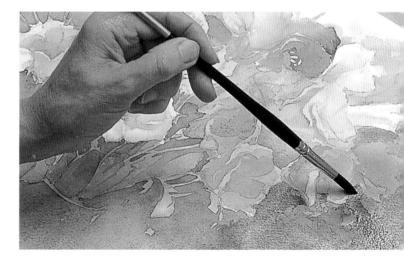

Dry brushing

Dry brushing involves working with the minimum amount of paint on the brush, and is useful for creating textured effects on foliage and petals. A small amount of paint is picked up on the end of the brush with the hairs splayed, resulting in a series of fine lines.

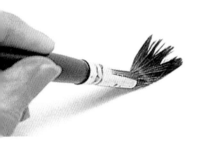

Brush position

To achieve the broken-colour effect, aim to open up the hairs in the brush so that they fan out, then press the bristles right down to the ferrule.

Broken colour

Dry-brush work is the ideal technique to use for the broken-colour effect of many flowers. Dip the brush in clean water and press out the excess water on spare paper. Dip the brush into the paint and splay out the bristles on spare paper. Starting at the petal tip, drag the paint down, fanning the colour out to the edges and tapering the brushstrokes at the petal base.

Petal markings

Using a dry brush is a good way of producing fine petal markings. Here, a dry brush was spread between the finger and thumb and dabbed in dryish paint, then used to paint the fine lines on these petals.

Brushmarks

For many watercolour flower artists, considerable emphasis is placed on brushwork, with features of flowers and foliage painted using separate, individual marks. It is a good idea to get to know your brushes and the various marks they can make by practising on spare paper. Vary the pressure on the brush so that the paint is drawn out toward the end of the stroke, or try twisting the brush so that the stroke is not uniform in shape.

Painting lines

Accurate work is possible by simply painting lines, or drawing with the brush. Experiment with different hand positions: holding the brush near the end of the handle gives a loose, free stroke, while holding it near the ferrule allows maximum control and can result in tight work.

1. Dip the brush in the paint and drag a line along the paper, letting the natural flow of the brush create the line. Notice that pressing the brush down gently, to use the broader middle part, widens the line, while touching just the tip creates a thin line.

2. Experiment with different sizes of brush to produce different thicknesses of line.

Painting dots

Pick up just a little paint with the tip of the brush and apply it to the paper, varying the pressure to create light and dark feathery marks.

Painting a petal shape

This shape, which could be a petal or a leaf, requires two strokes. Pull the first one downwards from the point at the tip, pressing the brush down to the bottom of the shape, before lifting the brush to reverse the stroke so that it meets the first at the starting point.

Spattering

Spattering is a method of flicking or spraying droplets of paint onto the surface and is used to suggest texture or to create random splashes of colour. Dip a brush in paint and run your finger through the bristles to release it in droplets. A toothbrush can be used for a coarse spatter.

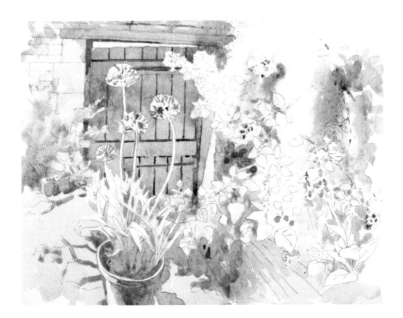

Jane Leycester Paige *Courtyard Garden*

A great way to describe the fleeting, shimmering effects of light on foliage is to place small dabs of colour side by side, leaving areas of white to show through, rather than using one flat colour. You can build up the effect by making little dots and dashes with the brush, and keep it fresh and clear by leaving each brushstroke to settle into the grain undisturbed.

Highlights

Highlights represent the points of light most intensely reflected from the surface of an object, and they add sparkle to a watercolour rendering. In watercolour work, highlights are usually created by retaining the white of the paper, or by lifting off colour in the final stages of the painting. Alternatively, small highlights that are virtually impossible to reserve can be added with white gouache or achieved by masking.

Reserving whites

The light reflecting from white paper is an integral part of a watercolour painting, and the most effective way of creating pure, sparkling highlights is to 'reserve' any areas that are to be white by painting round them. This means that when you begin a painting you must have a clear idea of where the highlights should be. Here, a strong blue wash was painted around the light-catching lower petals, followed by two yellow washes on the back petals.

Reserving lighter shapes

Not all highlights, of course, are pure white, and you may want to reserve areas of an initial wash. When the first wash is dry, paint the second tone, reserving the lighter markings.

Using white gouache

Gouache is the opaque version of watercolour, and can be tinted with watercolour if pure white is not required. Avoid diluting the gouache so much that it does not cover the earlier colours. Use the paint sparingly, as it dries matt and can look dull beside a watercolour wash.

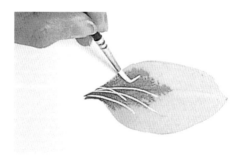

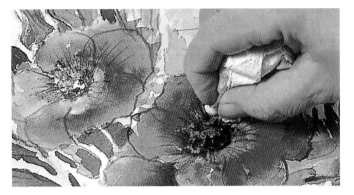

Lifting out

An alternative method to reserving whites or light areas is to lay a wash then lift out parts where required. You can do this using various implements, depending on the effect you desire and the wetness of the paint. To create soft, indefinite highlight areas, dab a tissue into still-wet paint to gently lift it out.

Scratching out

Also known as 'sgraffito', scratching out can be a precise method of applying small linear highlights and details. The most common method of scratching out is to use a sharp knife to scratch into dry paint, revealing white.

Masking

Use masking fluid to block out areas from a covering wash, either retaining white or protecting colour from a subsequent layer. Masking fluid is especially useful for fine details and using it allows you to work freely without the worry of paint splashing over the highlight areas. Simply apply it with a fine brush to the areas you wish to reserve as highlights. When the wash is dry, you can leave the masking fluid in place, or rub to remove.

Tutorial *Using masking fluid*

Masking fluid is used extensively in this painting of a poppy field, allowing plenty of freedom in the early stages of the work. The artist works in this way in order to combine freely applied texture with the detail that appears at a later stage of the painting. The result is an amazing carpet of colour and textures.

1. The horizon line and poppy heads are lightly drawn in, so that the flowers are small in the background and larger toward the foreground. The poppy heads are then painted with masking fluid, using fine spatter for those in the far distance.

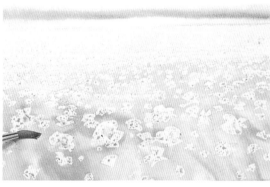

2. When the masking fluid is dry the sky and field are painted wet-in-wet.

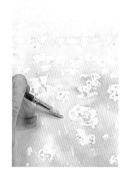

3. When the first washes are dry, masking fluid is spattered and drawn in broken lines into the foreground, and allowed to dry.

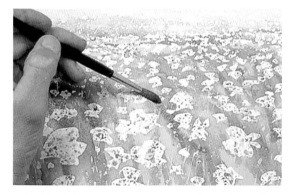

4. Vertical strokes are used to loosely brush in the next washes.

5. A toothbrush is used to spatter more masking fluid into the foreground. The aim is to produce as much texture as possible.

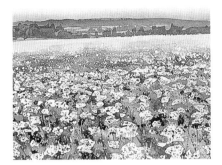

6. The painting is now built up. Brushmarks that suggest shapes and forms in the grass are added in the foreground, and hills and trees painted in the distance.

7. All of the masking fluid is now carefully removed, taking care not to tear the paper.

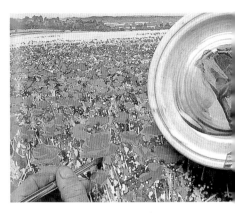

8. The poppies are painted using yellows and reds, adding detail to the nearer flowers and leaving plenty of white highlights in the distance.

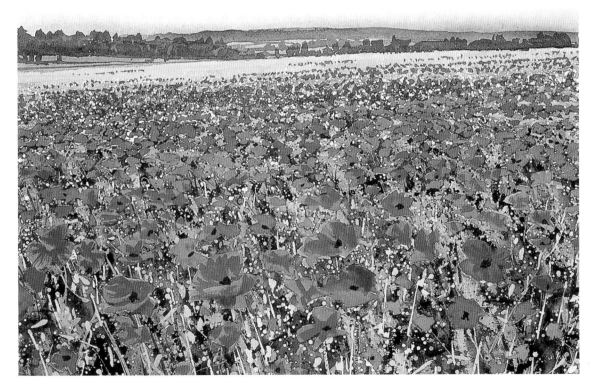

Joe Francis Dowden *Poppy Field*

The painting is a carpet of colour, but the use of spattering has kept the textures looking natural and random. The flowers appear vividly alive, wavering in the wind.

Tutorial *Experimental techniques*

Watercolour can be used in many different ways, it provides a fertile field for personal experimentation. The techniques used for this painting include scattering salt into wet paint, pushing plastic wrap into it, pulling out colour with a twig and applying paint with fingers; ideas that may inspire you to try out some unusual methods of your own.

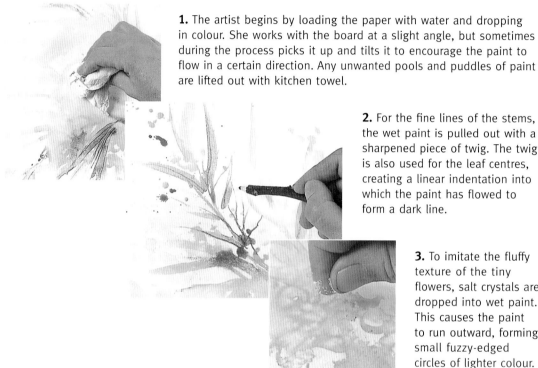

1. The artist begins by loading the paper with water and dropping in colour. She works with the board at a slight angle, but sometimes during the process picks it up and tilts it to encourage the paint to flow in a certain direction. Any unwanted pools and puddles of paint are lifted out with kitchen towel.

2. For the fine lines of the stems, the wet paint is pulled out with a sharpened piece of twig. The twig is also used for the leaf centres, creating a linear indentation into which the paint has flowed to form a dark line.

3. To imitate the fluffy texture of the tiny flowers, salt crystals are dropped into wet paint. This causes the paint to run outward, forming small fuzzy-edged circles of lighter colour.

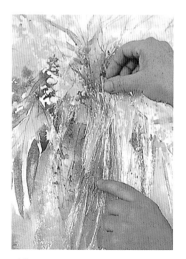

4. The vase shape is thoroughly wetted and a strong blue loaded on. To achieve the effect of the stems seen through the clear vase, a piece of plastic wrap is pulled into creases, pressed down and left in place for about twenty minutes before being removed. The pigment gathers around the creases and dries to form lines.

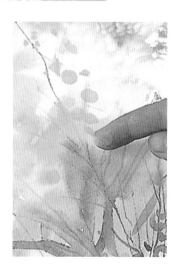

5. For the small flowers in the centre, silhouetted against the light background, a finger is used to dab on paint straight from the tube.

Judy Linnell *Mimosa*

In the foreground, the artist has encouraged watercolour's tendency to form backruns. This adds to the impression of freshness and spontaneity that expresses the subject so well.

Composing flower paintings

When you are ready to tackle the process of painting full-scale floral groups, you will need to consider various aspects of composition. Whether you choose to paint a still life indoors, or work in a flower's natural habitat out of doors, you are in control of the subject and can arrange the components of the picture any way you choose. So give some thought to how you will compose the subject. Have the end result in mind and work out how best to achieve it.

Begin by analyzing the shapes, trying to see the main areas of light and shade in blocks. Then take into account the various compositional considerations that help to ensure a flower painting is successful, such as cropping options, shape and pattern, and how to lead the eye.

Cropping options

You can try out various cropping options using a viewfinder made from two L-shaped pieces of card. Your subject will usually suggest the shape – portrait or landscape – but it is a good idea to try both. Cropping will allow you to focus in on any part of a flower for a dramatic view or pull back to take advantage of more complicated shapes and patterns. Bear in mind that any element of the composition cut by the frame of the painting will be brought forward into the picture plane.

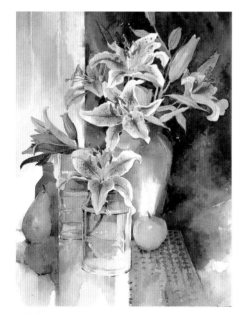

Visual pathways

Most paintings have a centre of interest, known as a focal point, to which the viewer's eye is led by a series of visual 'signposts'. The western eye reads a composition from left to right, and has a natural tendency to follow a diagonal line. Here the table edge acts as the first signpost' from which we travel upward through the curve of the apple to the gentler curve of the vase and finally to the focal point, the main group of flowers.

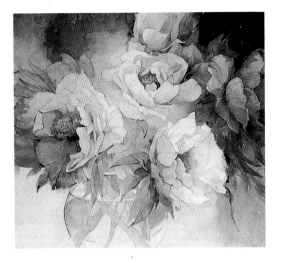

Composing with shapes

As you look at your subject, try to forget about the petals and leaves initially, but concentrate on the main shapes, viewing them as an abstract arrangement rather than specific objects.

A contrast of shapes – for example, a rough oval of flowers contrasted with a straight-sided vase – can give a sense of drama to a painting, while a more restful impression is created by repeated shapes, especially curves. The flowers in this painting form a series of curves, and the artist has cleverly chosen this unusual round vessel to ensure that the theme runs right through the painting.

Negative and positive shapes

Look at not only the positive shapes of the flowers, but also the negative shapes around and in between them. Here the use of a large area of negative white space in the foreground helps to draw the eye in, and the positive edges of the pale flowers are given their shape by the dark background that cuts in around them.

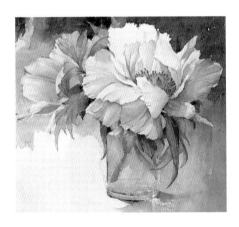

Backgrounds

The background in a flower painting gives depth and solidity to the flowers and can be used to change colour emphasis, lend atmosphere and give life to the subject. The blue background here emphasizes the bright yellow of the daffodils and including a lot of white will also help keep the colour scheme fresh.

Chapter Two
Studying flower shapes

You do not need to be a botanist to paint flowers, but by understanding their basic structure and shapes you can avoid frustration when it comes to depicting them successfully. Most flower heads can be broken down into one of eight basic shapes, each of which is examined in detail in the following pages.

Bell

The bell-shaped flower has a strong shape based on a rounded cone. Many bells hang down, bending over at the top of the stem, while others are upright and grow out almost at right angles to the stem, either clustering around a central point or spaced at intervals down it.

Bells are generally seen with the light striking the upper dome and dark areas of shadow in the interior. Therefore, pay particular attention to the way the stem joins the flower, its curve and colour and the character of the stamens inside the bell – sometimes just a tiny dot, sometimes a thrusting cluster of spikes.

Petal edges will be very light against the dark interior, and should be sharply defined. Some might be smooth and curved, others ragged and uneven, and the front edge should be sharper than the back edge.

Painting bell-shaped flowers

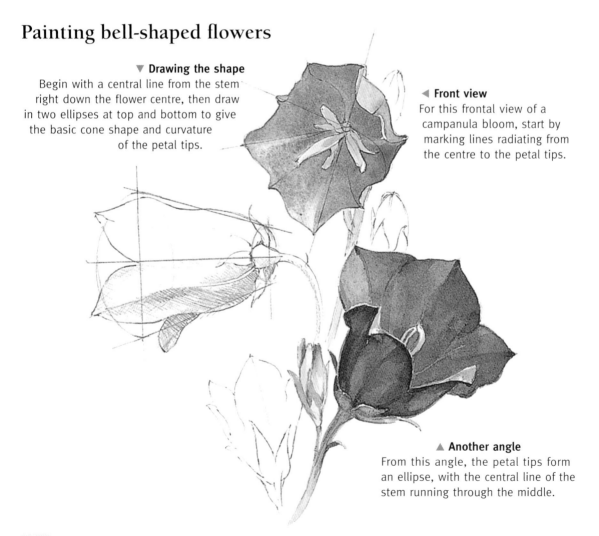

▼ Drawing the shape
Begin with a central line from the stem right down the flower centre, then draw in two ellipses at top and bottom to give the basic cone shape and curvature of the petal tips.

◄ Front view
For this frontal view of a campanula bloom, start by marking lines radiating from the centre to the petal tips.

▲ Another angle
From this angle, the petal tips form an ellipse, with the central line of the stem running through the middle.

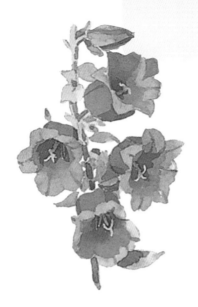

Light and dark

When seen from the side, petal edges will appear light against the dark of the inside of the bell.

Analyzing the structure

The bell-shaped flowers of the Spanish bluebell are arranged in a long curving line up the main stem. Each floret has two bracts at the base of the short stalk that unite it with the main stem.

1. Each individual floret is a bell shape that hangs down from a central stem. The floret is segmented into six flaring petals at the tip. Deep inside, in shadow, are the stamens, with the bottom edge of the petals catching the light. A small stem, together with two bracts, attaches the floret to the cylindrical stem.

2. Note how the individual flower shapes overlap in an alternate arrangement around the stem. They are more widely spaced at the bottom, clustering together toward the top. Paint the foreground flowers first to establish the shape.

Trumpet

A simple trumpet resembles a cone – roughly elliptical at one end and narrowing to a point. The area inside the flower is dark, with stamens at the bottom that draw the eye in and give definition to the base of the cone. The petals usually curve outward toward the tip to form the trumpet shape.

Use dark tones for the inside of the trumpet. The stamens will indicate the tubular nature of the flower, so use very dark tones for the shadowed areas between them, and notice the shadows that they cast. Keep the trumpet shape in mind to help work out the curling back and the hollow at the centre.

Painting trumpet-shaped flowers

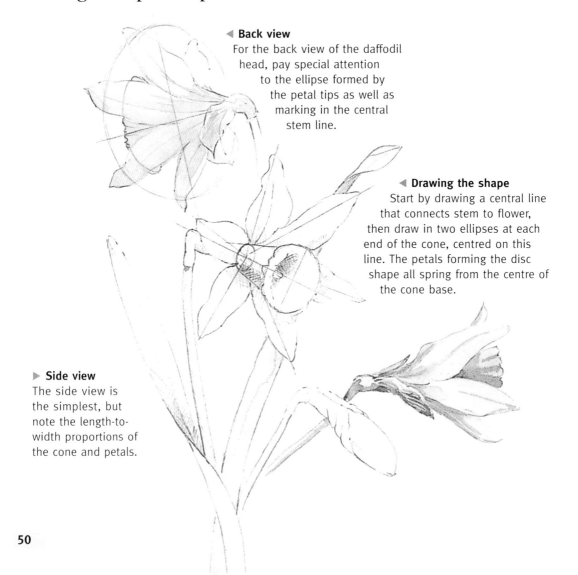

◀ **Back view**
For the back view of the daffodil head, pay special attention to the ellipse formed by the petal tips as well as marking in the central stem line.

◀ **Drawing the shape**
Start by drawing a central line that connects stem to flower, then draw in two ellipses at each end of the cone, centred on this line. The petals forming the disc shape all spring from the centre of the cone base.

▶ **Side view**
The side view is the simplest, but note the length-to-width proportions of the cone and petals.

Face-on

Seen face-on, the shapes of the
flower evolve into concentric circles,
and it is the deepening shadow that
defines the depth, with the stamens
providing perspective.

Volume and shape

The enormous cone-shaped flowers
of angel's trumpets hang down from a
stem and flare out widely at the bottom
to form the trumpet shape, with the
style protruding like the clapper in a
bell. In this painting, a well-defined side
light helps to reveal the volume and the
deep shadow inside, which sometimes
catches a shaft of light on the back inner
edge of the flare. The rendering of the
tubular shape stresses the roundness of
the form. The inside of the trumpet is
in shadow, but the tones, although
dark, are richly coloured.

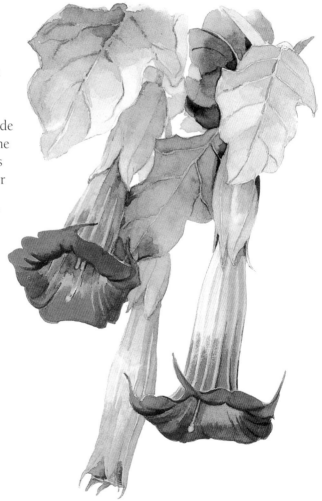

Multiheaded

Multiheaded flowers are among the hardest to paint because the whole is made up of many parts. Always start with the overall shape, which may be a sphere, a spike, a cone, or a tight ball shape, and then analyze the basic shape of the florets and the structure of the flower head. Often the florets are arranged in an umbel, each borne on a little stem radiating from one point. Imagine that you can see through them and follow the line around the back and sides, constructing as you paint. One of the secrets of painting a complicated multiheaded flower is to paint areas close to the eye in strong colour and sharp details, and to make distant blossom pale and hazy.

Painting multiheaded flowers

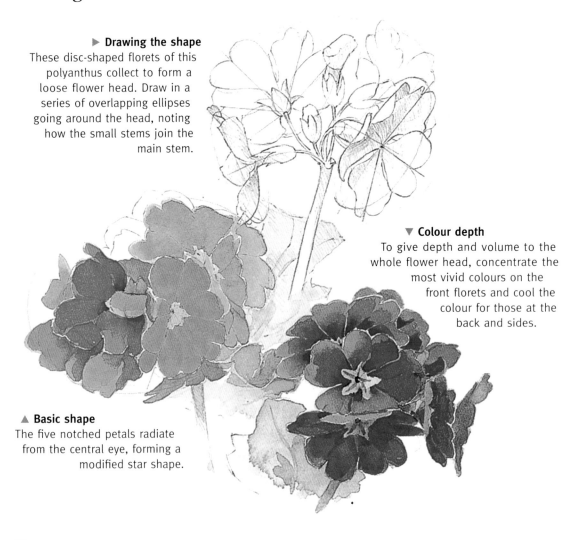

▶ **Drawing the shape**
These disc-shaped florets of this polyanthus collect to form a loose flower head. Draw in a series of overlapping ellipses going around the head, noting how the small stems join the main stem.

▼ **Colour depth**
To give depth and volume to the whole flower head, concentrate the most vivid colours on the front florets and cool the colour for those at the back and sides.

▲ **Basic shape**
The five notched petals radiate from the central eye, forming a modified star shape.

Analyzing shapes

The individual florets of a rhododendron are shaped like a cone and grouped together on a single stem to form a dome. Be aware of this overall spherical shape and note how the light affects it before engaging with the separate florets.

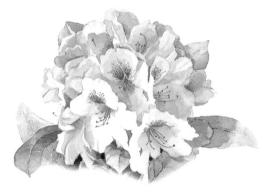

1. The flower heads are so densely packed that it can be difficult to see the cone shapes of the individual florets. These are arranged around a central stem, meeting at just one point on it. To suggest this, vary the planes and angles. Here, the main florets are shown as a series of ellipses, with the central one the widest.

2. In its simplest form the flower head can be thought of as a ball or sphere, and the placing of the shadows must emphasize this feeling of roundness. Reserve the darkest tones for the shaded right side of the sphere and the crevices between the florets.

Mass of colour

The tiny individual florets of the lilac flower are tubular in shape and achieve their spectacular effect by the way in which they are thickly massed together to form large, cone-shaped spikes or panicles, offset by fresh-looking light green, heart-shaped leaves. When painting, always try to convey the solidity of the basic cone shape, looking for the play of light on this basic form. Think too about how much detail you want to include; you may only need to describe a few florets to give a good impression of the flower.

Spike

This type of flower is a simple pointed cylinder, with many small florets attached to the central stem. Some spikes consist of a series of flower blocks and leaves set at intervals on a stem.

To draw the main shape, half close your eyes so that you are not distracted by detail and can concentrate on the main mass and the colours. Then look closely at each floret, its form and the shadows it casts on surrounding florets and pick out some areas to depict in detail, bearing in mind that you may only need to pick out a few of them.

Painting flower spikes

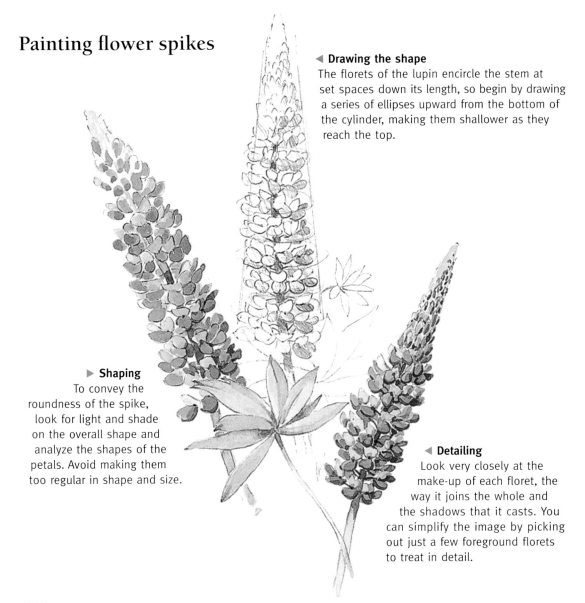

◄ **Drawing the shape**
The florets of the lupin encircle the stem at set spaces down its length, so begin by drawing a series of ellipses upward from the bottom of the cylinder, making them shallower as they reach the top.

▶ **Shaping**
To convey the roundness of the spike, look for light and shade on the overall shape and analyze the shapes of the petals. Avoid making them too regular in shape and size.

◄ **Detailing**
Look very closely at the make-up of each floret, the way it joins the whole and the shadows that it casts. You can simplify the image by picking out just a few foreground florets to treat in detail.

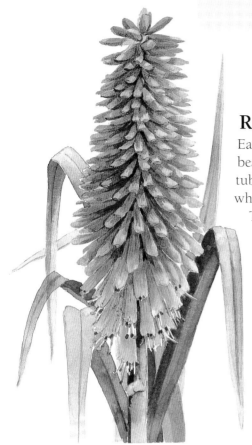

Round spike

Each stem of the red hot poker bears a dense terminal raceme of tubular bright orange-red flowers, which fade to yellow with age.

The flower spikes form a simple pointed cylinder, so to express this roundness of form, pay attention to the direction of light and look for the shade it casts on the overall shape. Notice also how the florets become smaller toward the top of the stem.

Richard French
Summer Breeze

However many flowers are on the stem, the principle of the basic shape is the same. You must then observe how that shape is divided. These hollyhocks have been painted in meticulous botanical detail, and their spikes varied from uprights to curves to give a feeling of life and movement. Notice that the higher up the stem the flower is, the smaller it is.

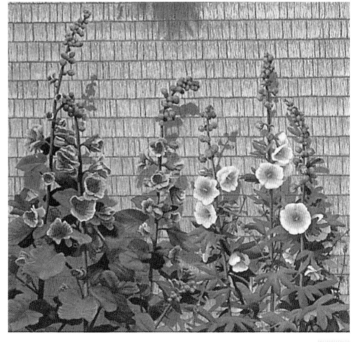

Rays and pompoms

These flower shapes are based on a circle, with petals radiating outward like spokes on a wheel. The ray shape is a simple disc seen as an ellipse when viewed at an angle, but pompoms are more varied, with a mass of small petals that spiral from a tight centre to form a dome or even in some cases a globe shape.

In each case, treat the flower as a whole rather than a cluster of individual petals. Having formed the basic shape, pick out a few petals to paint in detail.

Painting ray-shaped flowers

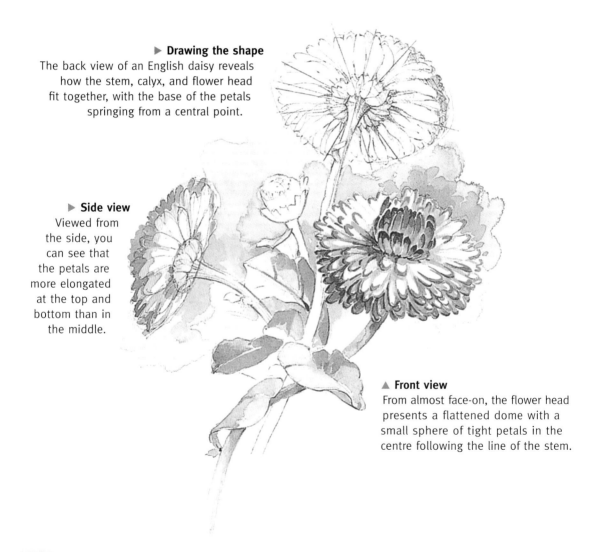

▶ **Drawing the shape**
The back view of an English daisy reveals how the stem, calyx, and flower head fit together, with the base of the petals springing from a central point.

▶ **Side view**
Viewed from the side, you can see that the petals are more elongated at the top and bottom than in the middle.

▲ **Front view**
From almost face-on, the flower head presents a flattened dome with a small sphere of tight petals in the centre following the line of the stem.

Ray structure

The full face-on view of the sunflower illustrates the ray principle perfectly and demonstrates how shadows give it form. Each petal is firmly anchored to the centre. When turned, the circle becomes elliptic. The stem and calyx need to be joined to the flower centre back, and the centre becomes domed.

Pompom structure

Some pompom-shaped flowers, such as this allium, feature many tiny flowers to one head. Think of pompoms as geometrical globes and add details in the later stages.

Perfect sphere

The long, thin petals of this dahlia are rolled lengthwise into quills. In spite of the seeming disarray of the petals, which point in different directions, the form of the flower is a faultless sphere. The overall shape of pompom flowers must always be kept in mind, with the feeling of roundness apparent even when many of the petals create their own light and shade.

Cup and bowl

This type of flower is basically half a sphere, varying from a tight cup to a wider, more open bowl. Just like a cup, the flower will form ellipses at the top and bottom. It is important to maintain the sense of volume, so always identify the basic structure before painting in the individual petals. Look carefully at the way the flower head sits on the stem, the nature of this junction and the positioning of the leaves on the stem.

Shadows are soft and delicately graduated on the upturned face of the flower, emphasizing the gentle curve of the petals, and dense and dark on the underside.

Painting cup- and bowl-shaped flowers

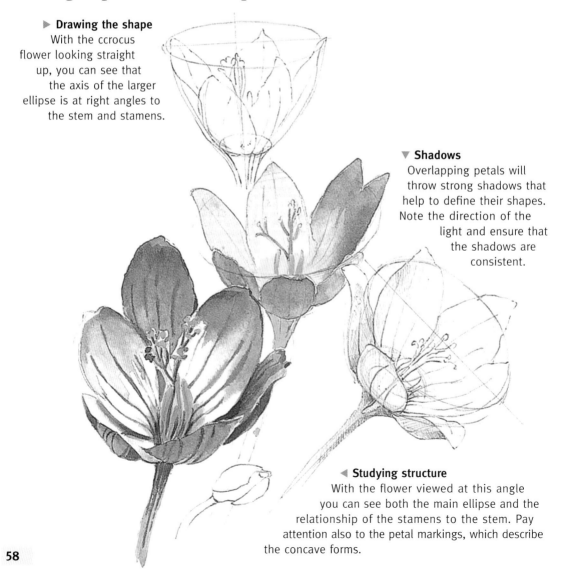

▶ **Drawing the shape**
With the ccrocus flower looking straight up, you can see that the axis of the larger ellipse is at right angles to the stem and stamens.

▼ **Shadows**
Overlapping petals will throw strong shadows that help to define their shapes. Note the direction of the light and ensure that the shadows are consistent.

◀ **Studying structure**
With the flower viewed at this angle you can see both the main ellipse and the relationship of the stamens to the stem. Pay attention also to the petal markings, which describe the concave forms.

Curved forms

The petals of the bowl-shaped flower spiral out from the centre and curve inward, throwing strong shadows that describe the forms. In this painting the artist has left some edges crisp and clear but softened others to give the impression of the gentle, rounded curves.

Shadow shaping

Consider how lighting affects a cup-shaped flower. Towards the centre of this rose the petals are concave, while the outer ones are convex. Drop in pale washes toward the right edge, and leave white paper for the areas catching most light. The shapes of the shadows and the colour variations are important. The surfaces of the petals curling into the centre are warm in colour, while the outer ones are relatively cool.

Lipped and bearded

All flowers are symmetrical, with their structures governed by a few basic rules. The majority of flowers are 'regular', but lipped and bearded flowers are called 'irregular', because they are unusual in being divided into two corresponding equal parts along a middle line running from top to bottom.

This type of flower bears close examination because even the most complex flower will reveal a simple underlying pattern. When cut in half, each side resembles the other exactly. When you have worked out the basic structure, then note the relative size of each petal, its texture and markings. As petals bend away from the light source and where they overlap, there will be shadows, and the centre of the flower may be very dark both in colour and tone.

Painting lipped and bearded flowers

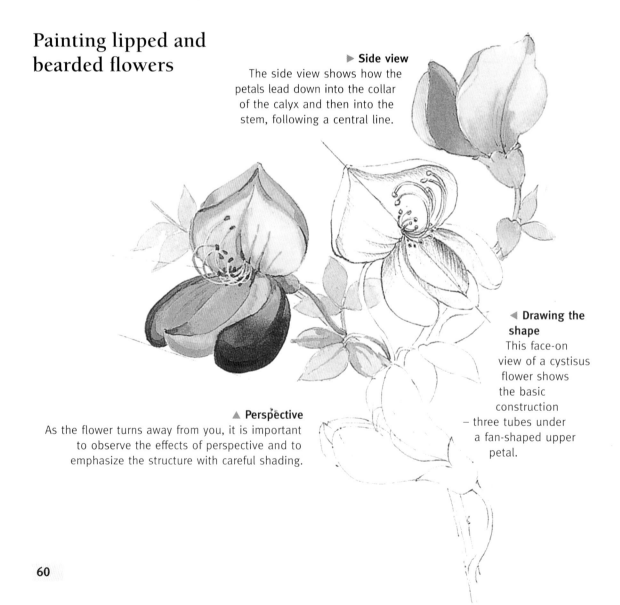

▶ Side view
The side view shows how the petals lead down into the collar of the calyx and then into the stem, following a central line.

◀ Drawing the shape
This face-on view of a cystisus flower shows the basic construction – three tubes under a fan-shaped upper petal.

▲ Perspective
As the flower turns away from you, it is important to observe the effects of perspective and to emphasize the structure with careful shading.

Simple star

When viewed straight on, these simple flowers can be seen as a flat circle with the petals – usually five – radiating out from the centre and arranged geometrically around the perimeter. They are grouped in different ways on the stem, some being single blossoms and others clusters.

Features to note are whether petals are each the same size, their texture, variation in tone and markings, and the character of the edges – ruffled, pointed or upturned. The flower centres are clearly visible and can range from a series of minuscule dots to an exploding burst of stamens.

Painting star-shaped flowers

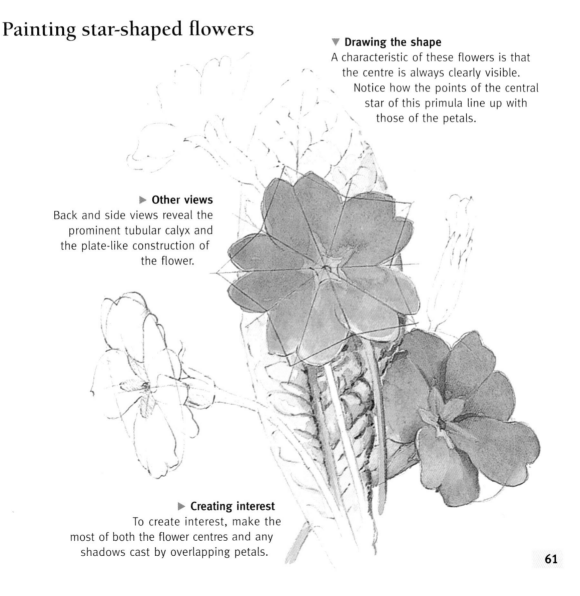

▼ **Drawing the shape**
A characteristic of these flowers is that the centre is always clearly visible. Notice how the points of the central star of this primula line up with those of the petals.

▶ **Other views**
Back and side views reveal the prominent tubular calyx and the plate-like construction of the flower.

▶ **Creating interest**
To create interest, make the most of both the flower centres and any shadows cast by overlapping petals.

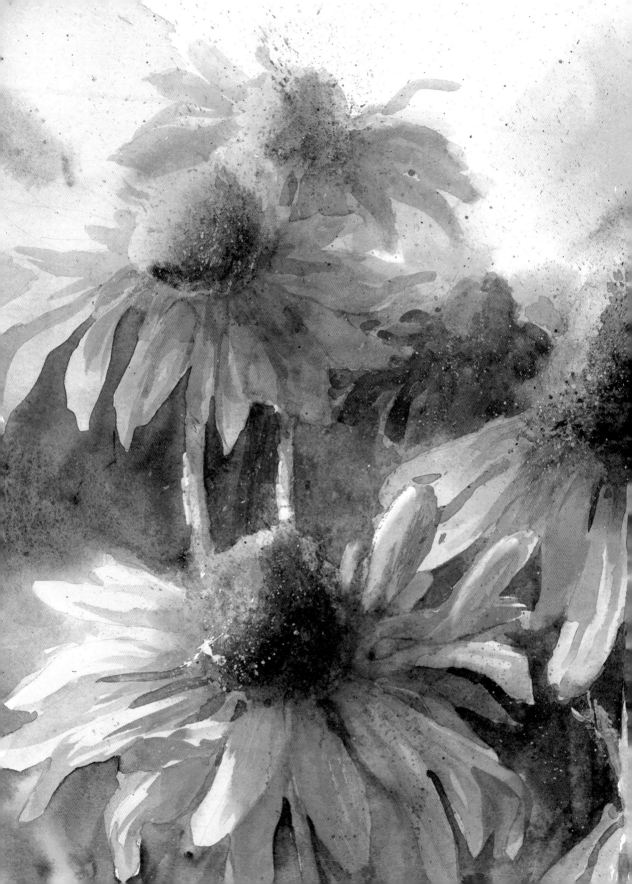

Chapter Three
Directory of flowers

The following section forms an invaluable reference for any watercolour flower artist. Here you will find step-by-step demonstrations for over 190 differenct flowers, berries and leaves, with artworks and captions detailing the colours used and important elements of the painting technique. The directory also features the work of a number of respected watercolour flower artists, to inspire and encourage both the novice and experienced watercolourist.

THE RED GARDEN

Day lily 74

Rosa moyesii 75

Carnation 75

Field poppy 76

Fuchsia 77

Hollyhock 77

Sweet William 78

Tulip 79

Calceolaria 79

Zinnia 80

Bottlebrush 81

Snapdragon 81

THE PINK GARDEN

Chilean bellflower 82

Fritillary 82

Poinsettia 83

Geranium 83

Lupin 88

Aster 90

Gerbera 89

Pulsatilla 90

Oriental poppy 91

Nerine 91

Rock rose 92

Foxglove 93

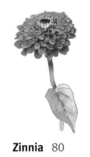
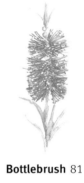
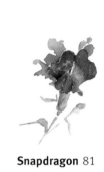
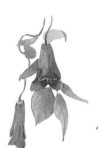
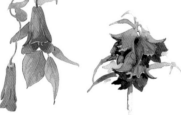

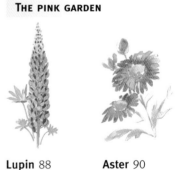
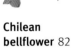
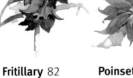

Gladioli 93

Alstroemeria 94

Camellia 95

Everlasting pea 95

Rhododendron 96

Dahlia 96

Rose 97

Lily 97

Pink 98

Red campion 98

Cyclamen 99

Sweet pea 99

THE ORANGE GARDEN

Nasturtium 104

Globe buddleia 105

Wallflower 105

Bird of paradise 106

Montbretia 107

Black-eyed Susan 107

Campsis 108

Crown imperial 109

African marigold 109

Day lily 110

Coreopsis 111

Iceland poppy 111

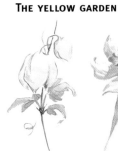
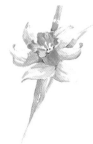

Chinese lantern 112 **Red hot poker** 112 **Chrysanthemum** 113 **Rudbeckia** 113 **Clematis** 118 **Daffodil** 119

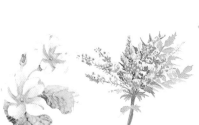

Primrose 119 **Mahonia** 120 **Buttercup** 121 **Iris** 121 **Achillea** 122 **Jonquil-narcissus** 123

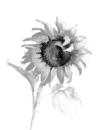

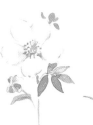
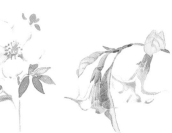
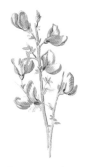

Sunflower 123 **Mullein** 124 **Potentilla** 125 **Angel's trumpet** 125 **Broom** 126 **Sweet mimosa** 126

THE GREEN GARDEN

Rosa 'Canary Bird' 127 **Witch hazel** 127 **Lily of the valley** 130 **Orchid** 131 **Lady's mantle** 131 **Flowering tobacco** 132

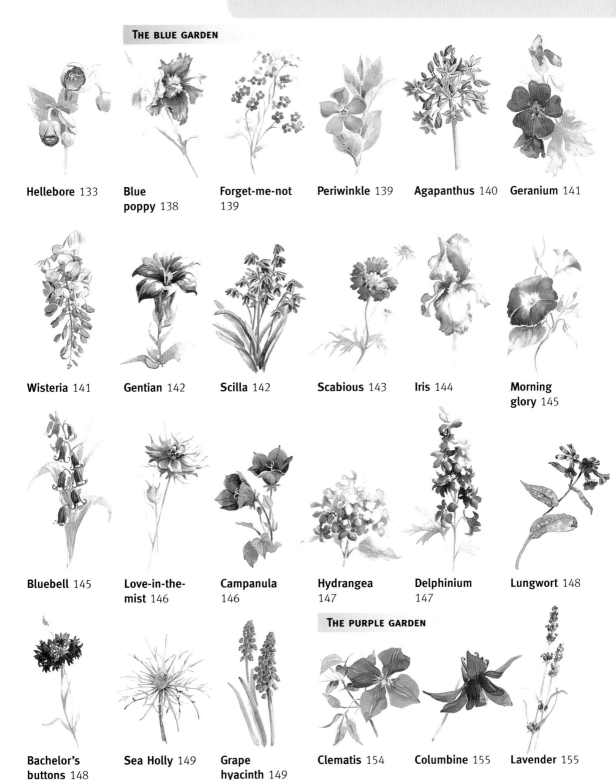

THE BLUE GARDEN

Hellebore 133

Blue
poppy 138

Forget-me-not
139

Periwinkle 139

Agapanthus 140

Geranium 141

Wisteria 141

Gentian 142

Scilla 142

Scabious 143

Iris 144

Morning
glory 145

Bluebell 145

Love-in-the-
mist 146

Campanula
146

Hydrangea
147

Delphinium
147

Lungwort 148

Bachelor's
buttons 148

Sea Holly 149

Grape
hyacinth 149

THE PURPLE GARDEN

Clematis 154

Columbine 155

Lavender 155

Allium 156

Black parrot tulip 157

Aster 157

Passionflower 158

Fleabane 159

Buddleia 159

Lilac 160

Hyacinth 161

Pansy 161

Anemone 162

Violet 162

Peach-leaved bellflower 163

Fritillary 163

Thistle 164

Hibiscus 164

Petunia 165

Michaelmas daisy 165

THE WHITE GARDEN

Heather 170

Water lily 171

Snowdrop 171

Prunus blossom 172

Apple blossom 173

Rose 173

Wood anemone 174

Frangipani 175

Lily 175

Honeysuckle 176

Daisy 177

BERRIES AND LEAVES

Peony 177

Shasta daisy 178

Calla lily 179

Mahonia 182

Snowberry 183

Cotoneaster 184

Firethorn 185

Primula 186

Fern 186

Tulip 187

Chrysanthemum 187

Poppy 188

Geranium 188

Rose 189

Ivy 189

The red garden

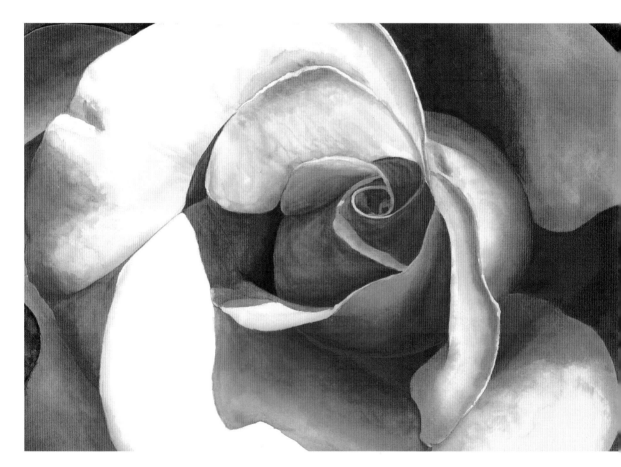

▲ **Maud Durland** *The Rose*

The artist chose to paint this flower straight on, in order to see the interesting layering of petals and the striking balance of light. Even though the centre of the flower is almost in the middle of the paper, the painting does not feel symmetrical because of the way in which the light hits the petals on the left.

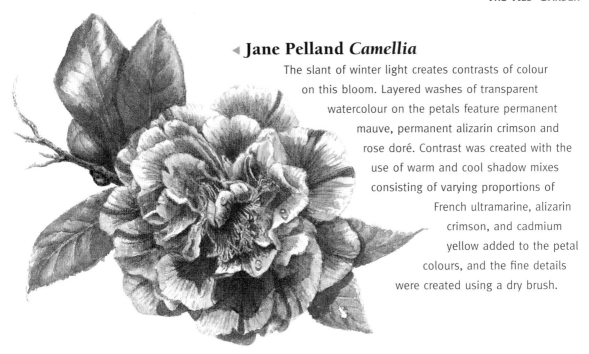

◄ Jane Pelland *Camellia*

The slant of winter light creates contrasts of colour on this bloom. Layered washes of transparent watercolour on the petals feature permanent mauve, permanent alizarin crimson and rose doré. Contrast was created with the use of warm and cool shadow mixes consisting of varying proportions of French ultramarine, alizarin crimson, and cadmium yellow added to the petal colours, and the fine details were created using a dry brush.

► Elena Roché *Epiphyllum Cactus Fruit*

This cactus was painted *en plein air* on an overcast day in the artist's garden, so strong shadows feature prominently. The subject was first lightly sketched with pencil, then each leaf and fruit was individually wetted and painted. The composition is influenced by Asian art.

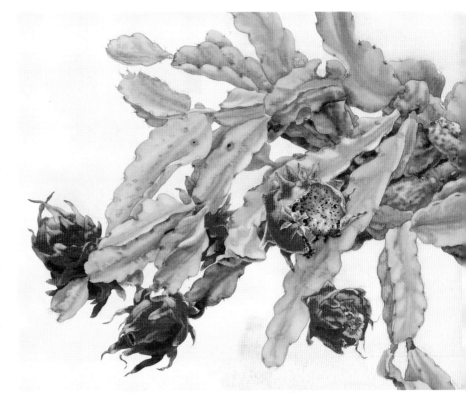

▶ Tracy Hall *Peony*

The leaves form a central role in this composition, leading the eye into and around the painting and balancing the intensity of the blooms. Strong shadows help to convey depth and form, and the sense of chancing upon the plant in a summer garden. Colour was built up in gradual washes, working wet-in-wet to blend the layers, while the fine veins and other details were added with a fine brush once the paper was dry.

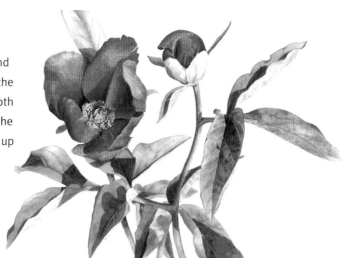

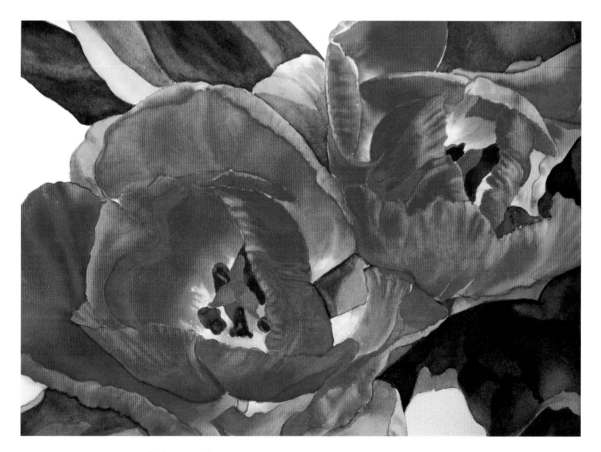

▲ Jana Bouc *Birthday Tulips*

The artist took a great number of photographs of tulips in a vase, adjusting the flowers and camera position in order to create a close-up composition with a three-dimensional effect and a sense of movement. Using a complementary red – green colour scheme for vibrancy, the artist worked wet-in-wet, one petal at a time.

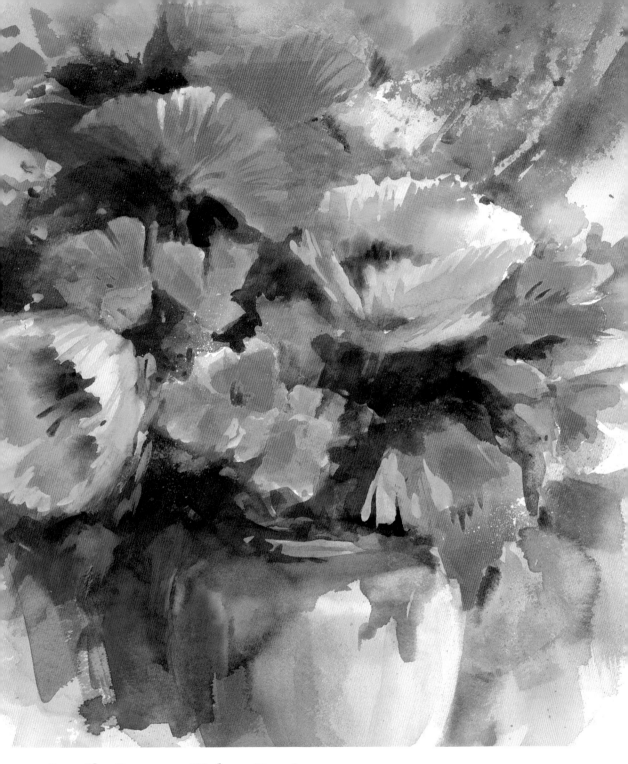

▲ Jennifer Bowman *High on Poppies*

The first layer of colours for this painting was placed wet-in-wet, while additional washes of cadmium orange and quinacridone red were added to make the colours 'pop' off the page. Suggestions of orange in the background with the complementary blues encourage your eyes to move through the painting.

Day lily colours

- quinacridone gold
- cadmium yellow
- alizarin crimson
- cadmium red
- permanent mauve
- pthalo blue
- sap green
- olive green

Day lily (*Trumpet*)

1 Mask out the central clump of stamens, then wash cadmium yellow into the throat of the trumpet and onto the outer edges of the front petals.

2 Paint the petals with a cadmium red and quinacridone gold mix, reserving lines of yellow. Paint the second flower in paler tones.

3 Paint petal accents with alizarin crimson, shadowing with permanent mauve. Remove the masking fluid and paint the anthers with cadmium yellow and the stamens cadmium red.

4 Use a mix of sap green, olive green and phthalo blue for the stalk and leaf.

The 'Stafford' day lily has six broad, deep mahogany-red petals.

Rosa moyesii *(Simple star)*

1 Paint small dots of masking fluid on the stamens. Dampen the petal shapes and drop in a bright red and permanent rose mix, then highlight the petals by lifting out some of the colour while still wet.

2 Build up the forms of the petals with a stronger mix of the same colours.

3 Touch in some alizarin crimson and permanent mauve behind the stamens and on some of the petal edges. Paint the centre with sap green and lemon yellow. Remove the masking fluid and tint the stamens with cadmium yellow.

4 Paint the branch with raw umber and colour the leaves with sap green and cobalt blue.

Carnation *(Ray)*

1 Paint a faint lemon yellow tinge on the upturned petals. Add a mix of permanent rose and bright red as the first wash. Allow the paint to pool on the lower edges.

2 Add a mixture of alizarin crimson and bright red to the deeper petals. Tip the paper to allow the paint to settle around the spiky edges of the light petals.

3 Continue adding darker paint to areas away from the light, tipping the paper to form crinkly edges. The deepest colours are an alizarin crimson and bright red mix, and alizarin crimson with a touch of ultramarine.

Field poppy colours

bright red

cadmium red

alizarin crimson

pale green-gold

indigo

sap green

cobalt blue

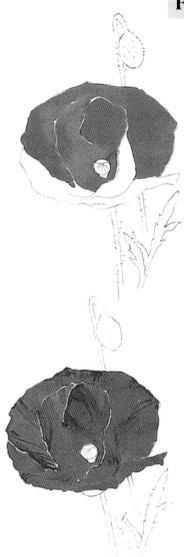

Field poppy (Cup and bowl)

1 Dampen each petal in turn with a brush dipped in clean water and drop in a mix of bright red and cadmium red. The paint will flow outwards, stopping when it meets dry paper.

2 While still damp, take up cadmium red on the tip of a fine brush and lightly draw lines following the curvature of the petals.

3 Darken parts of the petals with a strong bright red and cadmium red mix. Add alizarin crimson to the petal edges. Paint the dome in pale green-gold and the stamens and dome details with indigo.

4 Use a sap green and cobalt blue mix for the leaf, stem and bud, making the bud paler. Finally, touch in some hairs.

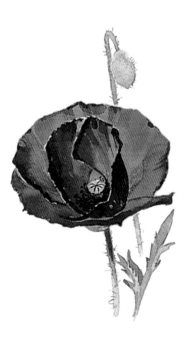

Fuchsia *(Trumpet)*

1 Paint the upper petals using permanent rose. Leave the highlights to indicate a shiny surface.

2 Add bright red to the darker areas and a strong mixture of this and permanent rose for the petal shadows. Wash dioxazine violet onto the lower petals and drop in a hint of permanent rose.

3 Use the same colours to reinforce the flower details.

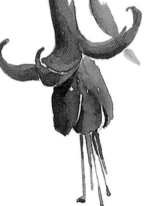

Hollyhock *(Spike)*

1 Touch in the flower centres with cadmium yellow and leave to dry. Wash over each flower with a mid-toned cadmium red, lifting out highlights on the lower petals.

2 Add deeper cadmium red in the shadow areas, softening the edges with a damp brush. While still wet, drop in a little alizarin crimson around the centre of the left-hand flower.

3 Build up the flowers with alizarin crimson, then add ultramarine and use a fine brush to touch in the central spots and vein markings.

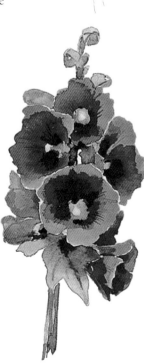

4 Use mixtures of sap green, olive green, and ultramarine for the leaf, stem and buds, making the colour darkest beneath and behind the flowers.

Sweet William colours

cadmium red

alizarin crimson

ultramarine

sap green

green-gold

Sweet William *(Multiheaded)*

1 Taking the brush outward from the centres, paint each floret separately with a mix of cadmium red and alizarin crimson, changing to a crimson and ultramarine mix on the lower petals.

2 Starting at the top, paint small dark shapes behind the petals with alizarin crimson, adding some ultramarine for the lower florets.

3 Build up the detail by painting the markings with strong crimson, then add ultramarine and darken the lower petals. Use the same strong mixture to crisp up the petal edges, using short, stabbing brushstrokes.

4 Paint the leaves with a mixture of sap green, green-gold and ultramarine, making them darker beneath the head.

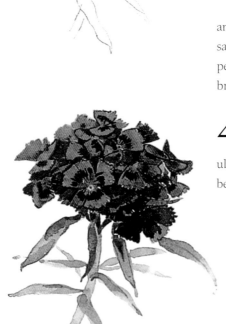

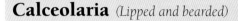

Tulip *(Cup and bowl)*

Calceolaria *(Lipped and bearded)*

1 Dampen each petal and drop in cadmium yellow and cadmium red, letting the colour pool toward the bottom of the flower. Add a touch of sap green as the paint dries.

2 Fill in further petals as before. Add a touch of alizarin crimson to the petal shadows.

3 Use the previous paints at full strength for the petal details.

1 Apply masking fluid to the small stamens, then paint the pouch of the flower with a fluid wash of cadmium red, allowing it to pool at the edges, While still wet, drop in a little cadmium orange at the top.

2 Complete the washes on both lips and reinforce the shadow by dropping in darker cadmium red wet-in-wet.

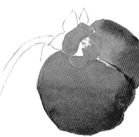

3 Paint the markings in alizarin crimson, adding permanent mauve for the shading. Use the same dark mixture for the flower throat. Rub off the masking fluid and tint the stamens with lemon yellow.

4 Paint the leaflets in sap green and olive green, and the stalk in two tones of olive green.

Zinnia colours

lemon yellow

permanent rose

bright red

alizarin crimson

cadmium red

permanent mauve

ultramarine

sap green

olive green

Zinnia (*Pompom*)

1 Lay a touch of lemon yellow in the centre, followed by a wash of permanent rose and bright red on the rest of the flower.

2 Mix bright red with alizarin crimson and start to outline some of the petals, concentrating the most colour on the shaded side so less of the first wash shows. Dab out colour at the top of the head where it catches the light.

3 Build up the petals with cadmium red and alizarin crimson, adding some permanent mauve to the mix for the touches of strong definition at the top.

4 Paint the leaf and stem with sap green, working in some lemon yellow wet-in-wet on the light side and an olive green and ultramarine mix in the dark shadow areas.

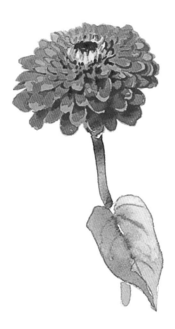

Bottlebrush *(Spike)*

1 Use masking fluid to block out the stamen ends. Only a few will show, but they will add sparkle to the strong red. Paint the stem in a mixture of lemon yellow and sap green, allowing the two to mix. Use a fine rigger brush and dryish cadmium red to create a mass of fine stamens.

2 Build up a second layer of stamens with bright red.

3 Add depth to the areas of shadow by adding brown madder to the mix, then remove the masking fluid with an eraser.

Snapdragon *(Lipped and bearded)*

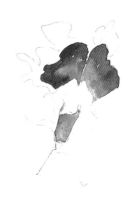

1 Dampen each petal in turn. Add a hint of cobalt blue to the lower edge. Add a mixture of alizarin crimson and cobalt blue just above, followed by alizarin crimson in the top half.

2 Use a touch of ultramarine to paint shadow in the second petal. Paint cobalt blue on the light side of the flower body. Use alizarin crimson and cobalt blue on the shadow side, allowing the two to mix.

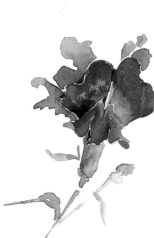

3 Use a bright red and alizarin crimson mix for the front petal. Paint the back blossoms and buds using a pale wash of the mixture used in Step 1. Lift out some parts of the front petal and add strong cadmium yellow to the flower centre.

Chilean bellflower (Bell)

1 Paint a wash of cadmium red mixed with permanent rose on the nearer petals, leaving thin lines of white, and dab out colour for the highlights. Build up the flowers with cadmium red on the petal tips and cadmium orange where they meet the stalks.

2 Paint in the back petals with permanent rose and just a touch of cadmium red, and dab lightly on the outer edges. Paint the second flower with a lighter mix.

3 Darken the bell's interior with an alizarin crimson and permanent rose mix, taking the paint around the stamens. Tint with Indian yellow, then add dark shadow edges to the top petals.

4 Paint the leaves and stem with a mixture of sap green, phthalo blue and olive green.

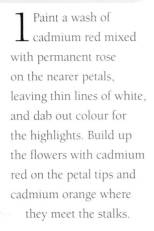

Fritillary (Lipped and bearded)

1 Paint a wash of alizarin crimson on the light-facing petals of the flower. Dab out light areas and build up the flower with cobalt blue and a mix of brown madder and ultramarine.

2 Paint the insides of the bells with brown madder and an alizarin crimson and ultramarine mix. Allow the paint to pool into the darkest areas.

3 Use a fine brush and various colours to add stamens, petal detail and dense paint to the inside depths.

Poinsettia *(Multiheaded)*

1 Paint dilute cadmium yellow where the light hits the petal tops. While this is still wet, drop in bright red.

2 Build up the other petals with full-strength bright red. Add a touch of brown madder where petals overlap.

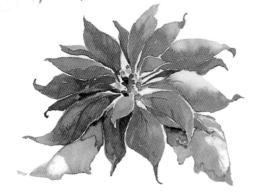

3 Wet each central brace and drop in cadmium yellow, bright red and sap green. Paint deeper washes of bright red and brown madder on the petals farthest from the light. Paint veins on a few to sharpen them up.

Geranium *(Simple star)*

1 Wet the petal shapes then drop in a mixture of permanent rose and bright red. Lift out paint from the light areas.

2 Paint a stronger mixture into the nearer petals and use very diluted paint for the far blossom.

3 Strengthen the shadows and petal veins with a full-strength mix, then add a touch of cobalt blue to the lower petal tips.

83

The pink garden

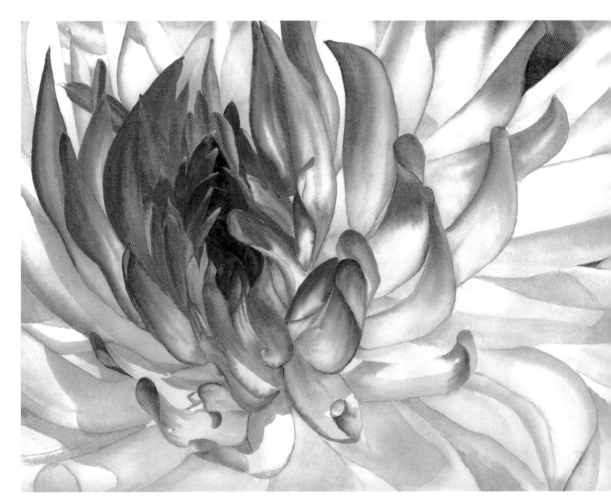

▲ Maud Durland *Dahlia*

The centre of this dahlia has been placed in the upper left part of the painting to make it the focal point of the work, while the close-up position gives an almost abstract feel. Colour was lifted out at the edges of the petals close to the centre to bring them forwards and to provide shape and volume.

◄ Jana Bouc *Rosy Glow*

The artist's primary focus when painting this rose was to capture its glowing colours. Working on one petal at a time, she first wet the area with water, then stroked in colour from a brush loaded with paint the consistency of cream. The artist then tilted the paper from side to side, letting the colours blend a little. Once each petal was dry, work began on the next.

► Jennifer Bowman *Pink Tulips*

Here, the artist has used an 'S' composition to lead the eye through the painting. The first layer of colours was placed wet-in-wet using washes of rose madder genuine and quinacridone red. Complementary colours of undersea green and rich green-gold were added to the wet page as well. The darker shapes between the tulips were cut in, keeping the deep shadow areas cool with washes of French ultramarine.

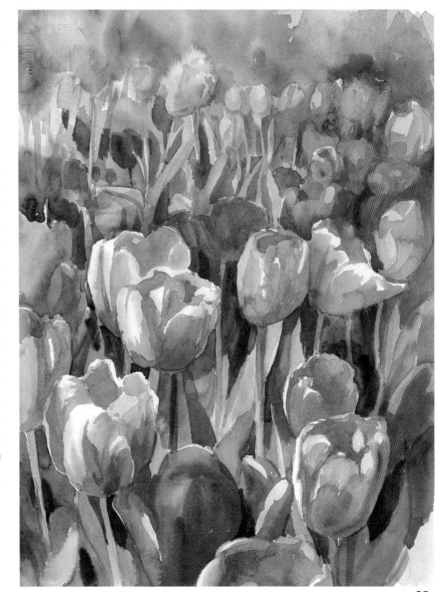

▶ Jennifer Bowman
Coneflowers

This started out wet-in-wet with quinacridone rose, phthalo blue and undersea green. A background of multiple layers of phthalo blue and green eases the eye into accepting the colour shifts from warm to cool, and the artist flicked accent colours mixed into gouache to give texture.

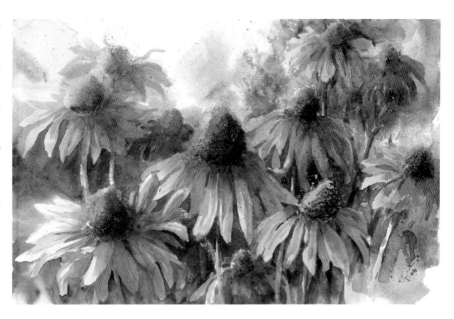

◀ Jana Bouc
Rose in a Bottle

Jana Bouc exaggerates the colours and shapes she sees in flowers and glass to make them more exciting to paint. Working from an enlarged photograph, she picked out the most interesting colours and shapes and painted them one at a time, sometimes wetting the area and dropping in paint, sometimes painting directly. The background was applied as a final step, with a flat, tapered brush (in order to get into the little spaces around the petals), creating a dark but richly coloured background that makes the flower stand out.

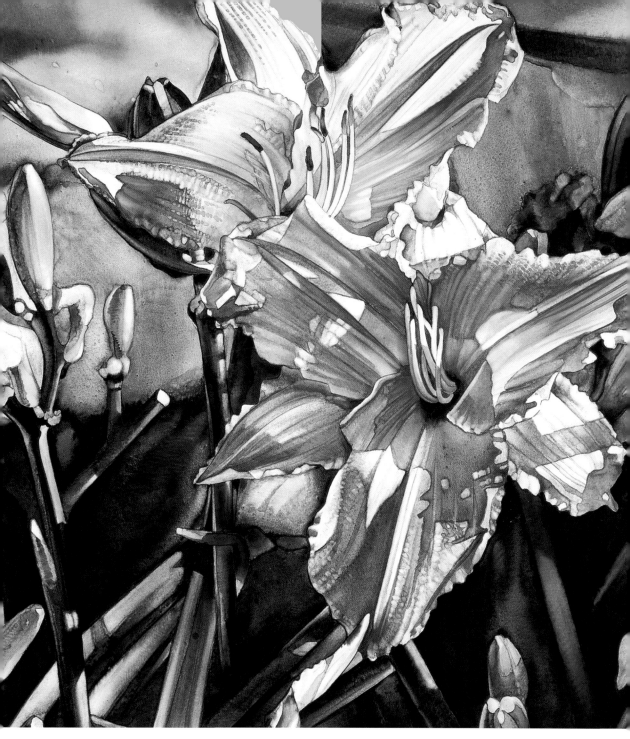

▲ Nancy Meadows Taylor *Duet*

The artist painted this pair of lilies from a photograph taken in the late afternoon, when the light was very warm and the shadows long and dramatic. The drama of the painting is further enhanced by the use of opposite diagonal thrusts in the composition, the foliage at the bottom left countering the leftward movement of the flower placement.

Lupin colours

green-gold

permanent
rose

cobalt blue

ultramarine

permanent
mauve

sap green

olive green

Lupin (Spike)

1 Starting at the top of the spike, wash in green-gold and lift out on the light side. Change to permanent rose, allowing this to mix with the green-gold.

2 Continue to strengthen the colour down the spike, adding cobalt blue to the permanent rose on the shadowed side. Start building up the floret shapes.

3 Add darker details with permanent mauve. At the top of the spike, outline the small buds with sap green.

4 Paint the palmate leaves and stem with a mix of sap green and olive green, adding ultramarine for the dark shadows.

The palmate leaves of the lupin are topped with compact spires or pea-like flowers.

Aster *(Ray)*

1 Paint the petals with a variegated wash of permanent rose, dropping in some Naples yellow on the upper and sun-facing petals.

2 Use stronger permanent rose for a second wash and add some cobalt violet to the lower petals. Paint the central disc lemon yellow, dropping in some brown-pink.

3 Sharpen and define some of the petals with strong colour, then use cobalt green for the leaves.

Gerbera *(Ray)*

1 Paint a variegated wash of lemon yellow on the sun-facing petals.

2 Use rose doré for a second wash, allowing it to settle in the shadowed areas.

3 Paint a little permanent rose onto some of the petals. Add burnt umber to permanent rose for shadows. Mix dioxazine violet with burnt umber for the flower centre and paint spikes of strong Indian yellow around it.

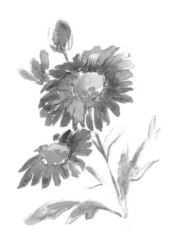

Pulsatilla colours

quinacridone
gold

permanent
rose

permanent
magenta

permanent
mauve

Pulsatilla *(Bell)*

1 Paint a strong wash of permanent rose over the top petals of the main flower, then use a dry brush to lift out some of the colour at the top.

2 Touch in quinacridone gold for the stamen boss. Shadow the lower petals using a mix of permanent magenta and permanent rose.

3 Using the same mixture, add shadow detail to the top petals. Deepen the mix with permanent mauve and paint inside the bell. For the background flower use paler mixtures of the same colours.

Oriental poppy *(Cup and bowl)*

1 Paint a pale wash of cadmium yellow onto the back petals. Use a watery mix of lemon yellow and permanent rose on the front petal.

2 Add more of the same mix as it dries, brushing the paint to make petal ruffles. Add a light wash of the mix to the back petals.

3 Use the same mix fairly dry to pick out petal folds and shadows. Paint the flower centre with a mix of cadmium yellow and dioxazine violet.

Nerine *(Multiheaded)*

1 Mask out the stamens then lay a pale wash of permanent rose separately over each floweret.

2 Paint a darker wash on the nearer petals and add cobalt blue for shadow.

3 Build up a flower head from the separate flowerets, using paler colours for distant blooms. Remove the masking fluid and add dark cadmium yellow stamens to the flowerets and use sap green for the stems.

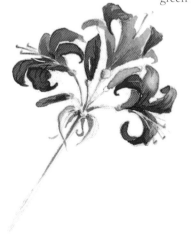

Rock rose colours

lemon yellow

cadmium yellow

raw sienna

cadmium red

permanent rose

permanent magenta

cobalt blue

sap green

olive green

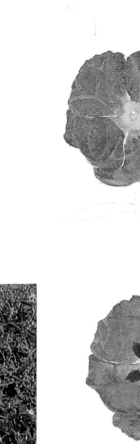

Rock rose *(Simple star)*

1 Paint the centre with cadmium yellow and leave to dry. Wet each petal in turn, leaving lines of dry paper separating each one, then quickly flood in a wash of permanent rose. Lift off colour in the centre up to the yellow.

2 Lay a sheet of plastic food wrap over the still-wet paint and gently press it down. Leave the paint to dry completely, then remove the plastic wrap.

3 Emphasize the light lines left by the plastic wrap by painting on either side of them. Add a thin glaze of cobalt blue in the shadowed areas. Paint the dark markings with cadmium red. When almost dry, dab in a permanent magenta and permanent rose mix.

4 For the stamens, paint dots of raw sienna mixed with permanent rose. Paint the leaves using mixes of sap green, olive green and lemon yellow.

The deep pink petals of the large rock rose flower resemble tissue paper and have a purple-brown mark at the base.

Foxglove *(Bell)*

1 Paint a light wash of permanent rose, reserving white highlights, and a second wash of permanent magenta.

2 Add further washes to build up the flower shape. Paint the pale shadow inside the flowers with a mix of cobalt blue and permanent rose and pick out the pattern inside the bell with a magenta and sap green mix.

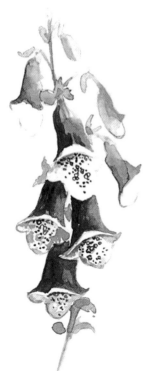

Gladioli *(Spike)*

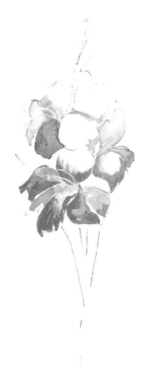

1 Start by masking the stamens. Working each petal separately, paint a variegated wash of permanent rose and bright red, allowing it to pool at the base of each petal. Touch some cadmium yellow in the centres.

2 Using a stronger mix of permanent rose and bright red, work the darker petals. Add some cobalt blue for the distant petals.

3 Use strong colour to paint the petal ridges. Remove the masking fluid and add sap green to the flower centres.

4 Mix sap green with phthalo green for the leaves.

Alstroemeria colours

lemon
yellow

cadmium
yellow

quinacridone
gold

cadmium
red

alizarin
crimson

permanent
mauve

cobalt blue

sap green

olive green

Alstroemeria (*Trumpet*)

1 Mix cadmium red with a little lemon yellow and lay a variegated wash, leaving linear white highlights. While the paint is still damp, add cadmium yellow to the pointed petals on the right.

2 Paint the trumpet and ridges on the yellow petals with an alizarin crimson and quinacridone gold mix, and add darker touches on the tips of the pink petals.

3 Use a stronger mix of the same colours to paint more petal ridges. Add permanent mauve, and paint the trumpet details, stamens and dark markings. Use quinacridone gold for the anthers, and paint the bud loosely with a combination of the previous colours.

4 Fill in the leaf and stalks with sap green, darkened with olive green and cobalt blue.

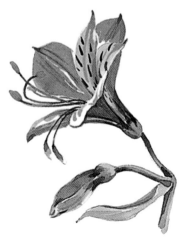

Camellia *(Cup and bowl)*

1 Begin by masking the stamens, then paint each petal with a mix of permanent rose and bright red, lifting out colour where the petals catch the light.

2 Touch in cobalt blue to the shadowed petals. Before the washes dry, dab the petal bases in quinacridone gold.

3 Create more shadow using a mix of permanent rose and permanent magenta. Soften the edges with the side of a damp brush. Remove the masking fluid and tint the stamens with raw sienna and cadmium yellow. Add magenta for the anthers.

4 For the dark leaves use mixes of cobalt blue, sap green and olive green, working wet-in-wet.

Everlasting pea *(Lipped and bearded)*

1 Wash over the fan-shaped upper petals with a mix of permanent rose and permanent mauve, then dab with a tissue to highlight.

2 Paint the small front petals with permanent rose. Use this colour also to add shadows and linear details on the upper petals.

3 Use a stronger version of the original mix to build up the flowers with darker accents.

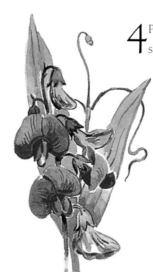

4 Paint the foliage, starting with a sap green and ultramarine mix and darkening with olive green.

Rhododendron (Multiheaded)

1 Paint a pale wash of cadmium yellow onto the sun-facing petals. Use deeper colour in the flower centres. Mask the stamens with masking fluid.

2 Dampen each petal in turn, then touch dry permanent rose onto the edges.

3 Paint the darker petals using permanent rose. Add a trace of permanent magenta for the petal shadows and cobalt blue for the darkest areas. Remove the masking fluid from the stamens and apply a raw sienna and cadmium yellow mix.

4 Use sap green for the leaves.

Dahlia (Pompom)

1 Begin painting the flower centre, using a mix of permanent rose and cadmium yellow, then change to permanent rose alone, gradually adding permanent magenta. Leave lines of white at the edges of the petals and dab out some colour from the centre.

2 Paint into the centres of the florets on the shaded side with a strong permanent rose and permanent magenta mix, but leave those at the outside edge as they are.

3 Using the same mix but darkened slightly with permanent mauve, continue to emphasize the florets, building up the centre with smaller strokes.

4 Use sap green on the stem, dropping in olive green for the dark shadow at the top.

Rose *(Cup and bowl)*

1 Wash the sun-facing petals with lemon yellow. Leaving some areas clear, wash a permanent rose and lemon yellow mix onto the mid-toned petals. Tip the paper to let it flow into deep areas.

2 Add cobalt blue for the darker petals. Use ultramarine and alizarin crimson with the mix for the darkest petals. Use the ultramarine and alizarin crimson mix to mould the petals and dry paint for the petal lines and points.

3 Add a touch of cobalt blue to the bowl of the flower. Mix sap green and cobalt blue for the leaves and stem.

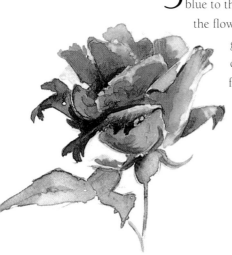

Lily *(Trumpet)*

1 Paint a strong wash of permanent rose onto the front petals, washing it out at the top edges.

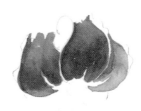

2 Mix in a little ultramarine and paint the deeper back petals. Deepen the shadow areas with the ultramarine and permanent rose mix before adding cadmium yellow to the stamens and flower centre. Darken this mix with permanent mauve to paint the trumpet details and dark markings.

3 Use varying mixes of cadmium yellow and sap green to paint the foliage, adding in a little cobalt blue for the stem.

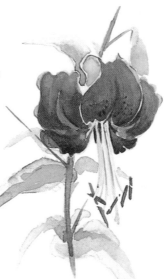

Pink *(Simple star)*

1 Paint a wash with a mix of rose doré and cadmium yellow, making it darker at the petal edges and reserving white highlights.

2 Add alizarin crimson to the rose mix and use this to reinforce the petal edges, by washing paint into the tips. Use shades of the same colours to paint petal lines and markings.

3 Add a cobalt green centre, stem and leaves.

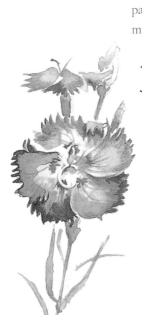

Red campion *(Multiheaded)*

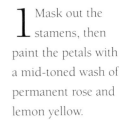

1 Mask out the stamens, then paint the petals with a mid-toned wash of permanent rose and lemon yellow.

2 Paint in the shadows on the light side with stronger permanent rose, and those on the dark side with permanent magenta.

3 Emphasize the flower centres with dabs of permanent mauve, then rub off the masking fluid and tint the stamens with raw sienna.

4 For the calyxes and stems, use a mix of sap green and alizarin crimson, finishing with a fine brush for the hairs. For the leaves, lay washes of sap green and cobalt blue, leave to dry, and add detail with a mix of olive green and sap green.

Cyclamen *(Trumpet)*

1 Use light washes of permanent rose to build up the petals, leaving the light areas as white paper.

2 Add a touch of cobalt blue to the darker areas and use strong rose doré for the petal pattern.

3 Lightly paint a wash of cobalt green on the leaf and stem. Use sap green for the dark pattern on the leaf and add rose doré to the stem.

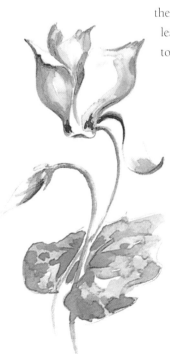

Sweet pea *(Lipped and bearded)*

1 Dampen each petal, then flood in a pale wash of permanent rose and lemon yellow. Push it to the edges of the petals and lift out the centres.

2 Add further petals in the same way, using a fine brush for details and petal ruffles.

3 Finish with sap green for the stem.

The orange garden

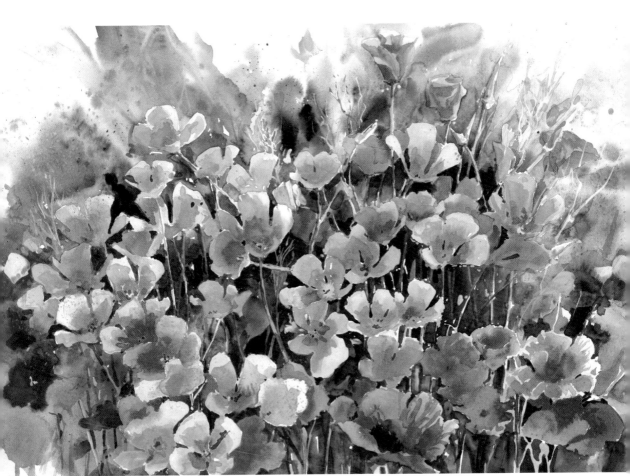

▲ Jennifer Bowman *California Poppies*

The artist has captured the fluorescent oranges and yellows of a field of California poppies, achieving an exaggerated contrast by placing a cool ultramarine wash in the background. She painted the background as a wet-in-wet wash, and later cut in the negative shapes between the foliage and described the stems.

◄ Elena Roché
Bird of Paradise

Elena Roché's compositions are often influenced by Asian art. This bird of paradise was painted *in situ* in afternoon sun. The subject was first lightly sketched with pencil, then each leaf and flower was individually wetted and painted.

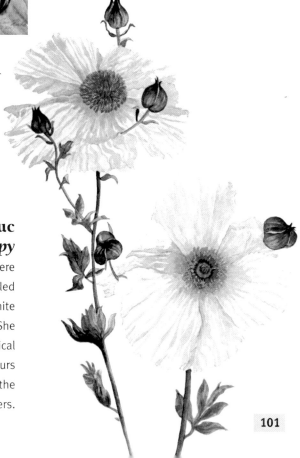

► Jana Bouc
Matilija Poppy

The brilliant orange centres of these poppies were painted with an especially small brush and controlled linework. The artist's goal was to paint a white flower on white paper without using white paint. She worked from a live specimen, aiming for a botanical illustration style, and painted the subtle, pale colours of the petals with small, round brushes to create the folds, shadows and dimensionality of the flowers.

▶ Tracy Hall
Purple Iris

The strong shape of the main flower dominates the painting, which plays on the complementary nature of purple and yellow-orange. The yellow-orange bud was added to reinforce this and help the purples to 'pop'. A careful tonal underpainting helps to create the illusion of sunlight and shadows.

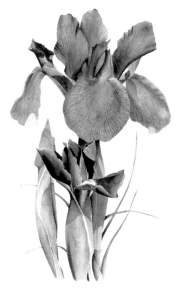

▶ Elena Roché
Canna

Roché chose a classical style of composition for this painting, which was sketched and painted in a shady position in the artist's garden. A resist was applied to the leaves, then each flower and leaf was individually wetted and painted.

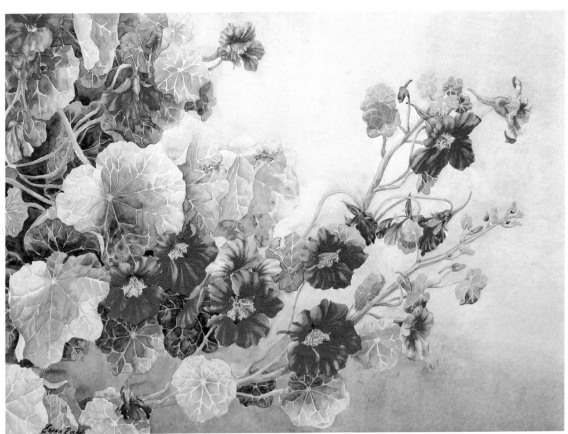

▲ Elena Roché *Nasturtiums*

These nasturtiums were painted in the artist's garden, in a shady position. After lightly sketching the Asian-influenced composition with pencil, each leaf and flower was individually wetted and painted, remarkably without the aid of a resist.

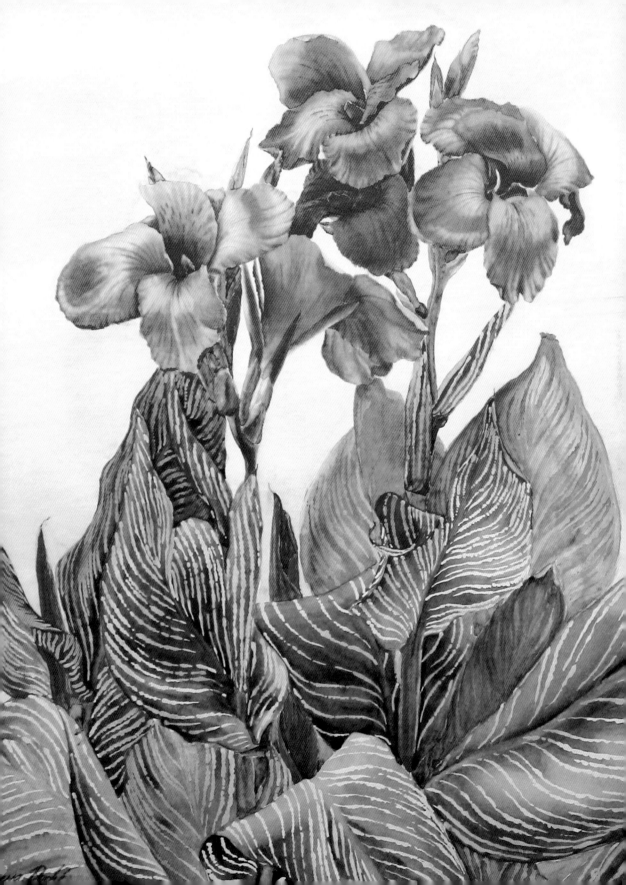

Nasturtium colours

cadmium
orange

alizarin
crimson

permanent
mauve

phthalo
blue

sap green

Nasturtium *(Lipped and bearded)*

1 Paint masking fluid over the beard and stamens. When dry, paint each petal with a loose wash of cadmium orange, leaving patches of white paper. Lift off colour on the tips of some petals to suggest the fall of light.

2 Shape the rounded petals with deeper cadmium orange and pick out some ridges.

3 Paint centre details with alizarin crimson, then intensify the colour by adding permanent mauve to the crimson. Remove the masking fluid then tint the stamens with pale cadmium orange.

4 Use a pale mix of sap green and phthalo blue to wash the leaves. When dry, paint over with a darker mix of those colours, reserving veins and light-struck areas.

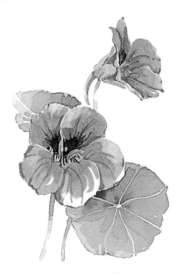

Nasturtium has large, spurred blooms.

Globe buddleia *(Multiheaded)*

1 Paint masking fluid on the edges of the florets. Suggest the globe shape with a wash graded from Indian yellow on top to cadmium orange at the bottom.

2 Lay a brushstroke of cadmium orange in the centre of each floret, the size of the strokes decreasing at the top where the form turns away.

3 Dot in the centre of each floret with a brown madder and burnt sienna mix. Rub off the masking fluid and tint the edges with lemon yellow down to cadmium orange and permanent magenta on the shaded side.

Wallflower *(Multiheaded)*

1 Paint the main petals using full-strength Indian yellow. Allow it to create strong edges. As it dries, touch raw sienna into the shadows.

2 Repeat for the other petals and use a fine brush to dampen areas and lift out highlights.

3 Use a fine brush to paint petal markings in burnt sienna and add stalks of sap green.

Bird of paradise colours

Indian yellow

cadmium yellow

cadmium orange

cadmium red

ultramarine

phthalo green

Bird of paradise *(Lipped and bearded)*

1 Wash Indian yellow into the front petals, then, as it dries, add cadmium orange.

2 Fill in the back petals, letting deeper cadmium orange flow into the bases. Paint the stamens using ultramarine and wash cadmium yellow and cadmium red lightly into the flower base.

3 Deepen the petal shadows using mixes of cadmium yellow and cadmium red and, to finish, dampen the flower base and flood in phthalo green.

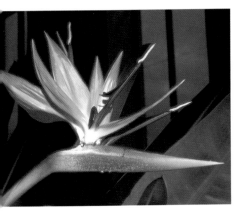

This exotic bloom resembles a bird's head, with a 'beak' of red-edged bracts and orange "feathers."

Montbretia *(Spike)*

1 Start by masking the stamens. When the masking fluid is dry, paint the petals with a variegated wash, changing from cadmium orange at the tips to cadmium yellow at the centre.

2 Build petal forms by shading with a brown madder and cadmium orange mix. Paint small buds with Indian yellow, then overlay with the same mix in the shadows.

3 Mix in brown madder and work into the trumpet centre. Use the same colour to create edges on the front petals. Rub off the masking fluid and paint the stamens with cadmium yellow.

4 Paint the stalks with sap green and darken under the flowers with olive green.

Black-eyed Susan *(Simple star)*

1 Paint each petal with a mix of Indian yellow and chrome orange. Lift out the centres to create sharp edges.

2 Add the black centres with an indigo and burnt umber mix.

3 Paint fine lines radiating from the centres in Indian yellow. On the darker side, allow the centre paint to blend in.

Campsis colours

Indian yellow

cadmium orange

brown madder

permanent mauve

sap green

olive green

Campsis (*Trumpet*)

1 Keeping the paint wet, paint an Indian yellow wash at the top of the flower, deepening it to cadmium orange at the bottom. Leave some white lines for the ridges. Add brown madder for the shaded side.

2 When dry, mix brown madder and cadmium orange. Apply in small strokes to suggest the papery texture, concentrating the colour more toward the bottom and on the shaded side.

3 Emphasize the ribs with brown madder and touches of cadmium orange.

4 For the leaf, lay a wash of olive green, adding some sap green wet-in-wet. When dry, paint finer details, then paint the stem with sap green and olive green.

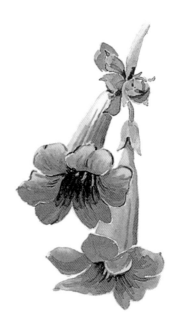

Crown imperial *(Bell)*

1 Paint a variegated wash of Indian yellow onto the main petals and a light wash of lemon yellow onto the stem and leaves.

2 Wash a mix of cadmium red and Indian yellow over the petals, reserving some white and yellow areas. Feed more paint in as it dries. Mask out the stamens.

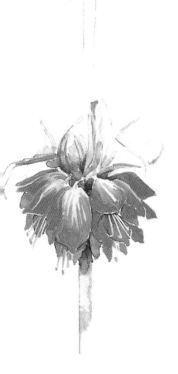

3 Add brown madder into the red and yellow mix and paint the lower petals, varying tone and shade. Remove the masking fluid and paint the stamens with Indian yellow.

4 Add dark sap green to the stem and leaves.

African marigold *(Pompom)*

1 Paint the whole shape with Indian yellow, deepening the colour at the centre and bottom with cadmium orange. Leave small patches of white, and avoid laying the colour too evenly.

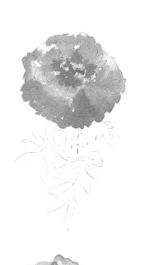

2 Start picking out some of the tiny petals with a mix of brown madder and cadmium orange. Hold the brush vertically and use the tip to outline the petals, making them larger at the front and bottom.

3 Continue outlining, this time using strong brown madder, then drop small touches of sap green into the centre.

4 Paint the leaves in shades of sap green and phthalo blue, adding some olive green at the top of the stem.

Day lily colours

Indian yellow

bright red

brown madder

Day lily *(Trumpet)*

1 Mask the stamens with masking fluid and apply a variegated wash of Indian yellow to the flower, leaving white highlights. Mix in a touch of bright red for the petal bases.

2 Add more bright red and paint the shadowed petals.

3 Use a darker mix to paint the petal ridges. Add brown madder and work into the centre of the trumpet creating crisp white edges to the front petals. Remove the masking fluid and paint light Indian yellow stamens.

Coreopsis *(Simple star)*

1 Paint dots of masking fluid for the stamens on the central dome. When dry, apply a fluid wash of quinacridone gold over the petals, leaving some white ridges.

2 As the paint dries, touch in stronger quinacridone gold to give shape and form to the petals.

3 Using a fine brush and a mix of quinacridone gold and green-gold, paint stronger shadows and ridges. Paint the central dome in sap green with touches of indigo. Remove the masking fluid and tint the stamens with lemon yellow.

4 Paint the leaves using crisp strokes of sap green and indigo.

Iceland poppy *(Cup and bowl)*

1 Paint a series of very pale washes in Indian yellow and cadmium orange. Drop in water to create ragged edges. Paint a deeper wash onto the lower petals with a touch of sap green at the base. Touch tiny areas of the petal edge with cadmium orange.

2 Deepen the lower areas. Fill in the flower centre and stem with an Indian yellow and sap green mix. Use very dilute paint for the shadow of the stem behind.

Chinese lantern (Bell)

1 Keeping the paint wet, paint an Indian yellow wash at the top of the flower, deepening it to cadmium orange at the bottom. Leave some white lines for the ridges. Add cadmium red for the shaded side.

2 When dry, mix cadmium red and cadmium orange. Apply in small strokes to suggest the papery texture, concentrating the colour more toward the bottom and on the shaded side.

3 Emphasize the ribs with cadmium red and touches of brown madder.

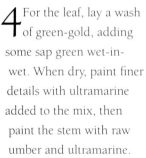

4 For the leaf, lay a wash of green-gold, adding some sap green wet-in-wet. When dry, paint finer details with ultramarine added to the mix, then paint the stem with raw umber and ultramarine.

Red hot poker (Spike)

1 Paint a multitude of petals radiating from the centre, using a bright red and cadmium yellow mix for the top petals and cadmium yellow for the lower petals. Allow the colours to mix slightly and dot cadmium yellow into the orange.

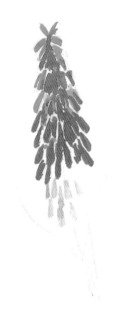

2 When dry, use a fine, firm brush to lift paint from each floweret. Use a mix of raw sienna and bright red to emphasize dark areas.

Chrysanthemum *(Ray)*

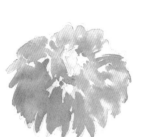

1 Think of the flower as a ball. Draw an outline of the whole flower head and fill it in with a loose wash of Indian yellow deepening to cadmium orange.

2 Add brown madder to the mix and dot it into the lower petals as they dry.

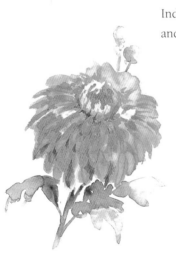

3 Lift petal shapes out of the dark paint. Add burnt sienna to the same colour mix for the details.

4 Paint the leaves in various mixes using Indian yellow, sap green, and phthalo green.

Rudbeckia *(Ray)*

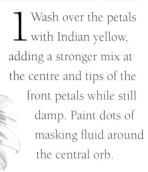

1 Wash over the petals with Indian yellow, adding a stronger mix at the centre and tips of the front petals while still damp. Paint dots of masking fluid around the central orb.

2 Using a mix of cadmium red and cadmium orange, paint from the centre outwards. Suggest ridges by feathering the paint out toward the petal tips. Use the strongest colour on the front petals.

3 When dry, paint darker ridges from the centre with a burnt sienna and brown madder mix. Paint the central orb with burnt umber and permanent mauve, lifting out a highlight. Rub off the masking fluid and tint the dots with cadmium yellow. Paint the stem using sap green.

The yellow garden

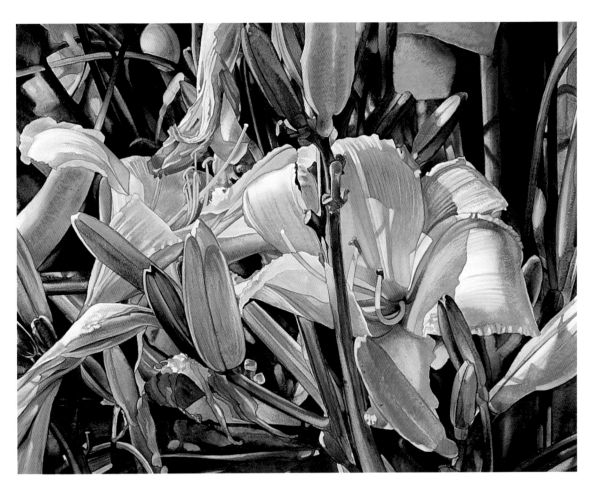

▲ **Nancy Meadows Taylor** *Summer Symphony*

The artist has worked on plate-finish Bristol board, a surface that paint sits on and is easily lifted from with a brush or sponge, allowing the image to be 'modelled'. The result is a painting that is energetic and strong in colour. Meadows Taylor works by dividing the image into manageable shapes, manipulating the paint within each shape until she is happy with the way it 'lies' on the surface.

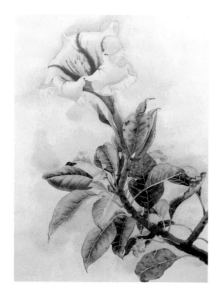

◄ Elena Roché
Solandra Number 3

The solandra, backlit by the afternoon sun, was painted in the artist's garden. The composition, influenced by Asian art, was first lightly sketched with pencil, then the flower and each leaf individually wetted and painted. A resist was used to create the veins in the leaves.

▲ Jennifer Bowman *Marguerite Daisies*

The artist's aim with this painting was to produce a suggestive and loose image. Starting wet-in-wet, plenty of new gamboge, quinacridone gold, and greens were placed into the initial wash. The darker colours – burnt sienna and alizarin crimson – were placed in as the wash dried, and salt was added to the centres of some of the sunflowers. The grape leaves and vines add movement to the bouquet, and the artist dropped colour into prewet stem shapes to suggest their gradations from greens to purples to reds.

Tracy Hall *Yellow Lily*

To ensure that the vibrant yellows of these blooms stay pure, the shadows have been laid down first in the tonal underpainting, which was then glazed over with washes of pure colour, preventing them from becoming 'muddied' or dull.

▲ Nancy Meadows Taylor *Adagio*

The artist has used a heavily pigmented underpainting for this work. For the first layer of underpainting a warm and a cool transparent colour were poured onto a wet surface and the colours allowed to mingle in some areas, while preserving the white of the paper in others. The second layer used a mixture of more opaque colours, again on wet paper, concentrating the mixture in areas of dark values and leaving the areas of light values open.

▲ **Jennifer Bowman** *Sunflowers 2005*

Painted in the fall, this bouquet of sunflowers was positioned in a south-facing window that was drenched in afternoon sun, giving a wonderfully false sense of warmth. Soft edges and smooth colour transitions are key, with only a few hard edges emphasizing the crisp, highlighted edges of the sun-tipped petals.

Clematis colours

Naples
yellow

lemon
yellow

raw
umber

sap
green

cobalt
green

Clematis *(Bell)*

1 Paint a lemon yellow wash over the petals, leaving some white highlights.

2 Build up the bell shape with cobalt green and raw umber touched into the drying paint.

3 Paint details into the leaves with a Naples yellow and raw umber mix and a sap green and lemon yellow mix.

Attractive silvery seed heads follow the yellow nodding bells of the golden clematis.

Daffodil *(Trumpet)*

1 Mix Indian yellow and Naples yellow and build up the petals with stripes of this mix. Leave white lines for petal ridges.

2 Wash Indian yellow into the trumpet shape. Push full-strength Indian yellow to the edges. Wash patches of chrome orange into darker areas.

3 Pick out the petal shadows using a mix of Indian yellow and raw umber. For dark areas of the trumpet add touches of strong raw and burnt sienna.

4 Use a lemon yellow and sap green wash for the leaves, and emphasize the strap leaves in a darker sap green.

Primrose *(Simple star)*

1 Flood each petal with lemon yellow. Before it dries, lift out highlights with a clean brush.

2 Leave to dry before painting in shadow areas with a mixture of green-gold and quinacridone gold, immediately softening some areas with a damp brush.

3 Paint the centres with cadmium orange and lemon yellow. When dry, touch each centre with green-gold, using a small brush.

4 Wash light sap green over the leaves and build up the forms with darker colour. Paint the veins with olive green. Darken the colour beneath the flower.

Mahonia colours

lemon
yellow

cadmium
yellow

quinacridone
gold

cobalt
green

sap green

olive green

burnt
umber

Mahonia (*Spike*)

1 Paint the spiky florets with a mixture of cadmium yellow and lemon yellow. Keep the edges broken and uneven.

2 When dry, paint quinacridone gold around the spikes' bells. Colour the leaflets behind the flower using a cobalt green and sap green mix.

3 Add some dark leaves behind the central spike using a sap green and olive green mix. Paint the stem in burnt umber.

Mahonia stems are topped with curving racemes of bright yellow flowers.

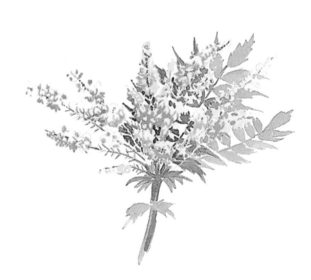

Buttercup *(Cup and bowl)*

1 Flood the light-facing petals with Indian yellow and lemon yellow and lift out the highlights as the paint dries.

2 Use an Indian yellow and brown-pink mix for the undersides of the petals.

3 Add cobalt blue to the mix and use it to sharpen the shadow lines. Add stamens in lemon yellow and leaves in sap green.

Iris *(Lipped and bearded)*

1 Drop cadmium yellow and Indian yellow into the petal and drop water in to spread the paint.

2 Use Indian yellow with a touch of raw umber to add petal detail and lift out the highlights on the front petal.

3 Paint the petal details with raw sienna, finishing with a mix of sap green and raw umber on the stem.

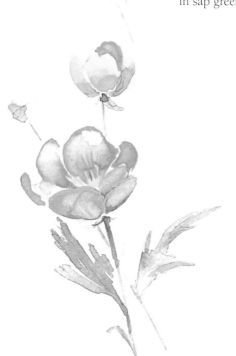

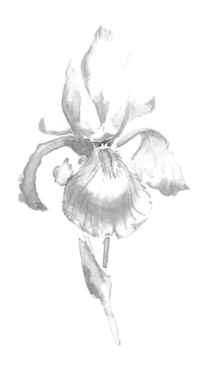

lemon
yellow

quinacridone
gold

ultramarine

cobalt
green

Achillea (Multiheaded)

1 Draw the whole flower head initially as one shape, then lay a lemon yellow wash over it. Lift out highlights with a tissue.

2 Dot in the flower centres with quinacridone gold, lightening them as they recede. Paint the leaves and stem with cobalt green.

3 With a cobalt green and ultramarine mix, carefully paint a suggestion of foliage behind some of the florets. Use the same mixture to add definition to the stems.

The flat, plate-like heads of achillea flowers are good for cutting and drying.

Jonquil-narcissus *(Trumpet)*

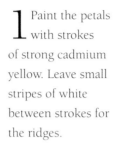

1 Paint the petals with strokes of strong cadmium yellow. Leave small stripes of white between strokes for the ridges.

2 Build up the petal forms using quinacridone gold and cadmium yellow. Wash cadmium orange into the small trumpet shapes.

3 Paint the sheath with raw umber. Use a mix of sap green and phthalo blue for the leaf and stems. Paint brown madder on the edges of the trumpets.

Sunflower *(Ray)*

1 Wash a mix of lemon yellow and Indian yellow into each petal. Add water to push the paint to the edges.

2 Mask out the highlights on the flower centre. Use Indian yellow and raw sienna to darken parts of the petals.

3 Dampen the flower centre and apply a wash of Indian yellow and burnt sienna. Remove the masking fluid and, as the paint dries, add burnt umber to the darker parts and a burnt umber and dioxazine violet mix to the darkest areas. As this dries, wash dark paint into the shadow areas of the petals.

Mullein colours

Naples
yellow

lemon
yellow

brown-pink

cobalt
green

Mullein *(Spike)*

1 Paint the flowers in various mixes of Naples yellow and lemon yellow. Drop water in to lighten the upper edges of the flower.

2 Pick out the stamens with brown-pink and add a Naples yellow and cobalt green mix for the shadowed petals.

3 Fill in the main and side stems with cobalt green, allowing it to mix occasionally with the yellow.

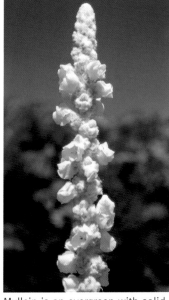

Mullein is an evergreen with solid spires of yellow blooms.

Potentilla *(Simple star)*

1 Flood each petal with lemon yellow. As it dries, move it to the petal tips and flower centre.

2 Add stamens with a mix of cadmium yellow and brown-pink, and sepals with a lemon yellow and cobalt blue mix.

3 Use the same colours, with more cobalt blue, for the bud and leaves.

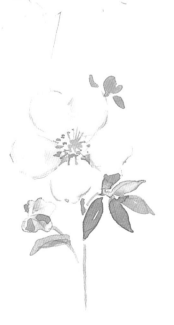

Angel's trumpet *(Trumpet)*

1 Lay a wash of lemon yellow mixed with Naples yellow evenly over the flowers. While still damp, lift out the highlights with a clean dry brush.

2 Paint sap green on the leaves. Before this paint dries, drop in lemon yellow on the tips. Let dry, then paint shadows on the right-hand flower with a mixture of raw sienna and cobalt blue.

3 Use the same shadow colours for the other flower, strengthening the mixture for the dark areas. Use sap green and olive green for the leaves and cups.

Broom *(Lipped and bearded)*

1 Paint a wash of cadmium yellow over the flowers. Before it dries, lightly drop in Indian yellow at the base of each flower so that it blends gently.

2 When dry, paint petal details using quinacridone gold. Paint the stems and leaves with a mix of sap green and cadmium yellow.

3 Mix a touch of burnt sienna with quinacridone gold and build up the flowers. Add a few lines to emphasize the forms of the petals.

4 Paint vertical lines on the stems with a sap green and olive green mixture, using touches of this colour to pick out details on the leaflets.

Sweet mimosa *(Multiheaded)*

1 Paint puddles of lemon yellow in varying strengths to show near and far flowers. Drop water into some parts to push paint to the edges.

2 Paint a skeleton of spray in pale green.

3 Build up the roundness of the nearer globes with Indian yellow and a mix of raw sienna and sap green.

4 Fill in the leaves and stems around the flowers with yellowy green.

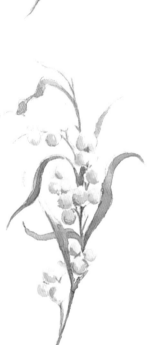

Rosa 'Canary Bird' *(Cup and bowl)*

1 Paint each petal with a lemon yellow wash, and gently lift out highlights with a tissue. While the paint is still damp, drop strong cadmium yellow around the centre of the flower and on the folded edges at the bottom and side.

2 Build up the petal shadows with a mix of cadmium yellow and cadmium orange.

3 Wash the leaves with sap green and highlight them using lemon yellow.

4 Dot in the anthers with brown madder, using a paler mixture for those at the back. Emphasize the orange centre with a dark sap green semicircle at the front.

5 To make the flower stand out, darken the leaves behind it with a sap green and olive green mix, and paint in a few veins with a fine brush.

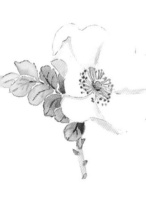

Witch hazel *(Pompom)*

1 Paint the clusters of long, narrow petals with crisp strokes of cadmium yellow, taking the brush out from the centre of each flower. Darken some with quinacridone gold, weaving the brush in and out.

2 Paint the flower centres with dots of burnt sienna, then wash in the branches with raw umber.

3 To convey the feathery impression of the flowers, parts of the branches must be painted between the petals, then darkened in places with a mixture of raw and burnt umber. Add burnt umber to emphasize the centres.

The green garden

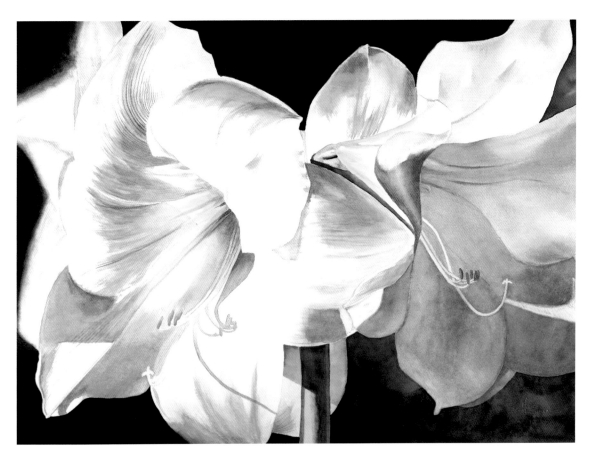

▲ **Maud Durland** *Amaryllis*

The sunlit area of the amaryllis is the focal point of this painting and a very dark background, painted wet-on-dry, makes the flower jump out from the page.

◄ Tracy Hall
Passion Flower

A preliminary drawing of this passion flower was carefully observed, not only to record the botanical details of the plant as accurately as possible, but to try to capture something of its character as well, like the tendrils interacting with the leaves and stem. The pencil lines are kept light, as they are eventually erased.

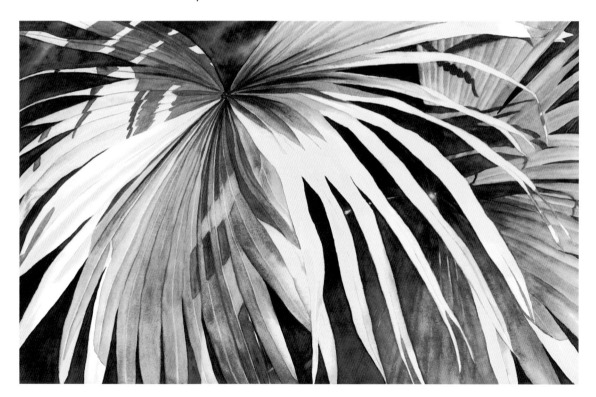

▲ **Maud Durland** *Palm Leaves*

This was a labor-intensive painting, as each section of the leaf was painted separately, some wet-on-dry, others wet-in-wet. After the first layer was painted, the artist added the centre lines, some of which were lifted out. The background is intentionally very dark, in order to allow the top leaf to 'pop'. A blue wash was placed over the third leaf so that it would fade into the background.

Lily of the valley colours

Naples yellow

lemon yellow

cobalt blue

phthalo green

Lily of the valley (Bell)

1 Begin by masking each bell shape. Paint a wash of lemon yellow, then a second wash, adding a touch of phthalo green. Paint a dark mix of phthalo green, Naples yellow and cobalt blue around the masked flowers. Add phthalo green stems.

2 Paint a cobalt blue wash over the darker leaf areas. Remove the masking fluid and touch each bell with Naples yellow before sharpening the details.

Orchid (Lipped and bearded)

1 Paint a pale wash of lemon yellow on each petal, followed by a second wash of lemon yellow and cobalt blue. Use a tissue to lift out the highlights.

2 Moisten the apron and paint the ruffle in alizarin crimson so that colour pools at the edges. Add fine crimson lines to the petals.

3 Use the same colours to build up tone and fine details.

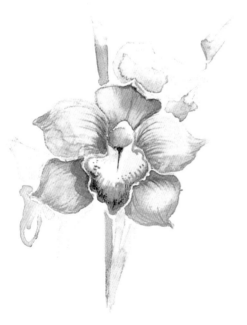

Lady's mantle (Multiheaded)

1 Make tiny stars with masking fluid for the lightest flowerets. Paint a wash of lemon yellow.

2 Add more masking fluid stars and apply a second wash, this time with cobalt blue added.

3 Add more cobalt blue to the mix to paint the top leaves. Add a little phthalo blue and paint the darker leaves and shadows.

Flowering tobacco colours

green-gold

phthalo
blue

indigo

sap green

Flowering tobacco *(Bell)*

1 Lay a light wash of green-gold all over the flowers and stems, then add more colour in the shaded areas. When dry, wash phthalo blue over the yellow on the underside of the petals of the top flower.

2 Paint in ridges down the trumpet and calyx with sap green, continuing the colour down the stem.

3 Add small details on all parts of the flowers with an indigo and green-gold mixture.

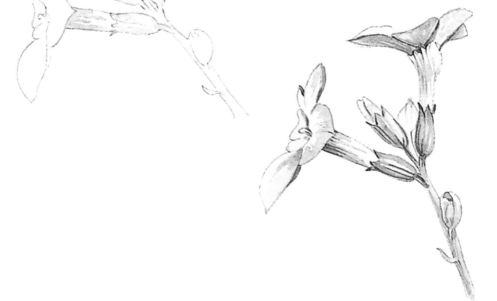

Hellebore (Bell)

Hellebore colours

1 Paint green-gold on the light-catching bells and leaves, blending in cobalt green wet-in-wet on the shaded sides, then touching in brown madder at the bottom of the petals. Add cobalt blue to the mix for the background leaves.

2 Mix sap green and phthalo green and paint the insides of the bells, then add cobalt blue and start to paint the dark areas on the leaves.

3 Intensify the green inside the bells using sap green mixed with indigo. Darken the leaves behind the bell with the same mix.

green-gold

cobalt blue

indigo

phthalo green

sap green

cobalt green

brown madder

Pendant clusters of apple-green, cup-shaped flowers are produced at shoot tips.

The blue garden

▲ **Maud Durland** *Farmers' Market*

The artist spotted these buckets of blooms positioned in bright sunshine at a farmers' market, and has painted around the white areas of the sunlit parts of the flowers. The background was painted wet-in-wet using the different colours of the flowers to unify the painting.

▲ Jane Pelland
Hydrangea

The artist made a quick thumbnail sketch of this flower in its natural setting, a garden in the historic district of Charleston, South Carolina, and took a number of photographs. She took a clipping back to the studio and began a very detailed series of sketches, beginning with the basic outer dimensions and filling in clusters of circles that in later sketches became the configuration of many petals. Layers of transparent washes define warm and cool areas cast by shadows, while fine details have been applied with a dry brush.

◄ Jennifer Bowman
Blue Monday

Layers of colours have been placed wet-in-wet, with lots of emphasis on tying in the background with the bouquet. Rose madder and French ultramarine have been dropped in to create wonderful blends of warm to cool blues and purples.

135

◄ Lizzie Harper *Bluebells*

Lizzie Harper is a botanical illustrator who turns her hand to a multitude of drawing and painting jobs. One of the remarkable aspects of this artist is the speed with which she completes a detailed study such as this bluebell painting. Unlike most flower artists, the painting technique here does not involve layers of translucent paint but is executed quickly in one layer using relatively dry and concentrated mixes of paint and ink.

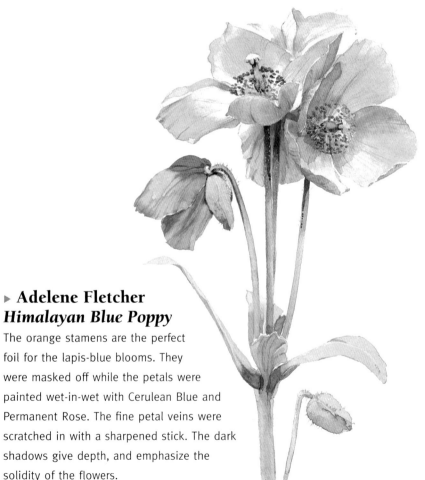

► Elena Roché *Blue Iris*

These irises were painted *en plein air* after a rainstorm, hence the bent and frayed leaves. The subject was first lightly sketched, then each leaf and flower was individually wetted and painted. The composition is influenced by Asian art.

► Adelene Fletcher *Himalayan Blue Poppy*

The orange stamens are the perfect foil for the lapis-blue blooms. They were masked off while the petals were painted wet-in-wet with Cerulean Blue and Permanent Rose. The fine petal veins were scratched in with a sharpened stick. The dark shadows give depth, and emphasize the solidity of the flowers.

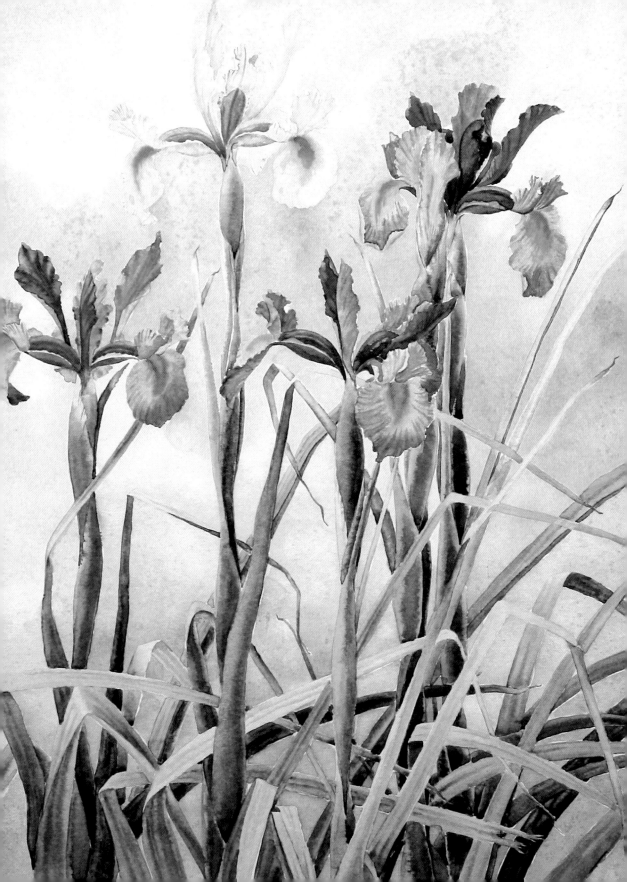

Blue poppy colours

lemon
yellow

brown-pink

phthalo
blue

cobalt
green

Blue poppy *(Cup and bowl)*

1 Paint a light wash of phthalo blue into each petal, leaving white highlights.

2 Add more phthalo blue and paint into some of the darker areas, pulling the paint into petal ridges.

3 Build up the flower centre with dots of lemon yellow and brown-pink, adding strong paint to the deepest areas. Paint the stem and bud in cobalt green.

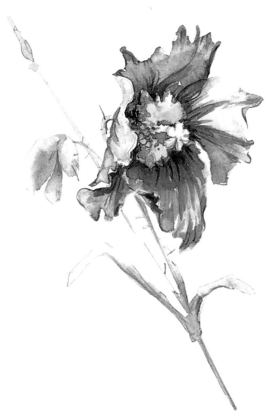

Forget-me-not *(Multiheaded)*

1 Using cerulean blue for lighter, distant flowers, and cobalt blue for closer, brighter flowers, drop dots of paint to create flower heads. Allow some of the dots to blend and add touches of permanent rose.

2 Add detail to some of the closer flowers and use cadmium yellow for a few flower centres.

3 Link all the flowers with sap green threads of stems.

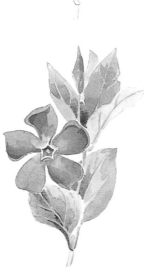

Periwinkle *(Simple star)*

1 Paint the petals and centre with a wash of ultramarine and dioxazine violet mix, lifting out highlights with a tissue.

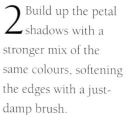

2 Build up the petal shadows with a stronger mix of the same colours, softening the edges with a just-damp brush.

3 Paint the bud with ultramarine and add darker ultramarine to the petals and the top of the star centre.

4 Paint the central spot with quinacridone gold, and mix this with phthalo green and cobalt blue for the leaves, varying the proportions so that the front leaves are warmer in colour.

Agapanthus colours

green-gold

permanent rose

dioxazine violet

ultramarine

indigo

sap green

Agapanthus *(Multiheaded)*

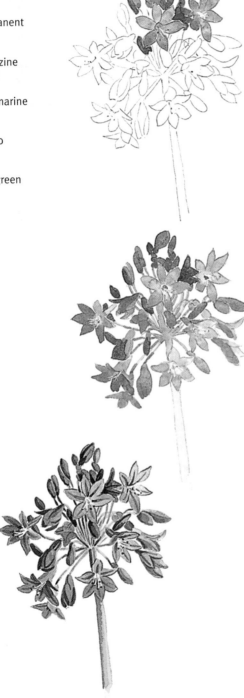

1 Mask out some of the stamens. Paint the flowers with diluted ultramarine. While wet, drop in pale permanent rose. As the paint dries, add more ultramarine to the throats.

2 Paint the floret stalks with sap green, lightened with green-gold, and drop sap green into the throats.

3 Build up detail with a mix of ultramarine and dioxazine violet and paint stripes down the open florets' petals. Rub off the masking fluid and tint the anthers with indigo.

4 Strengthen the stems and stalk with sap green to finish.

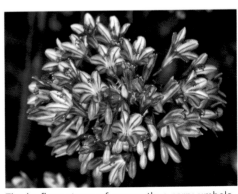

The leafless stems of agapanthus carry umbels of mid-blue tubular flowers.

Geranium *(Simple star)*

1 Paint a light wash of permanent rose with ultramarine onto the flowers. Add more paint as it dries to create an uneven effect.

2 Paint a second wash of ultramarine and build up the lower flower with petal shapes of watery paint.

3 Lift out some of the paint to create highlights. Pick out the petal veins with brown madder and alizarin crimson, working the paint with a dry brush into the shadowed petal bases.

4 Paint the leaves with sap green and phthalo blue.

Wisteria *(Lipped and bearded)*

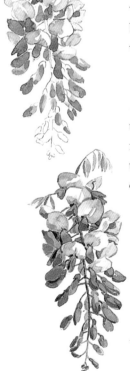

1 Paint a light wash of dioxazine violet on the upper lips of the open flowers, leaving white highlights. While wet, drop in quinacridone gold at the base of the lips.

2 Paint the buds and lower part of the open flowers with permanent mauve, dropping in cobalt blue while wet, using a damp brush to soften the edges where the lips meet.

3 Continue to build up the flowers, using two tones of permanent mauve and ultramarine, then define the centres by dotting in a mix of mauve and quinacridone gold.

4 Paint the stems and leaves with sap green, green-gold and olive green, and tint some of the floret stems with permanent magenta.

Gentian colours

cadmium
yellow

permanent
rose

ultramarine

phthalo blue

sap green

Gentian *(Trumpet)*

1 Establish the middle-toned petals with a variegated wash of phthalo blue. As this dries, touch in specks of permanent rose.

2 Use strong ultramarine for the darker areas, strengthening it further for the deepest tones.

3 Build up the trumpet with ridges of paint and add crisp edges.

4 Paint the leaves using a mix of cadmium yellow and sap green.

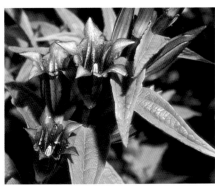

The trumpet-shaped gentian flowers grow from the leaf axils.

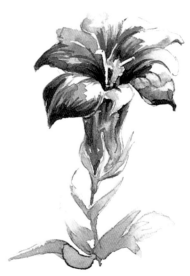

Scilla *(Bell)*

1 Paint the top petals in pale ultramarine, adding permanent rose. Paint the stems with a mix of sap green and permanent rose.

2 For the undersides of the flowers, use stronger mixes of the same colours, and add some background shapes between the flowers with cobalt blue.

3 Using a fine brush, paint the stripes down the centres of the front petals.

4 Use a mix of sap green and cobalt blue darkened with olive green for the leaves, then add shadows to the stems with sap green and permanent rose.

Scabious *(Ray)*

1 Begin by masking the stamens with masking fluid. Paint a delicate wash of cobalt blue mixed with permanent rose onto the petals. Drop in water to push the paint to the petal edges.

2 Add a darker wash of the same colours to the deeper-toned areas and shadows. Dot a pinker mix into the central dome and surround this with cobalt green.

3 Remove the masking fluid, then use various mixes of cadmium yellow, cobalt green, and phthalo blue for the leaves and buds.

Iris colours

lemon
yellow

cobalt
blue

dioxazine
violet

brown-pink

1 Dampen the petals and paint on a veil of lemon yellow. Add cobalt blue to the lower edges of the top petals, feeding in more paint as it dries. Paint bright lemon yellow anthers with touches of brown-pink.

2 Add a little dioxazine violet to the cobalt blue and paint the lower petals, reserving a white apron.

3 Build up the layers using the same paints, finishing with strong dioxazine violet for deep shadows and petal markings.

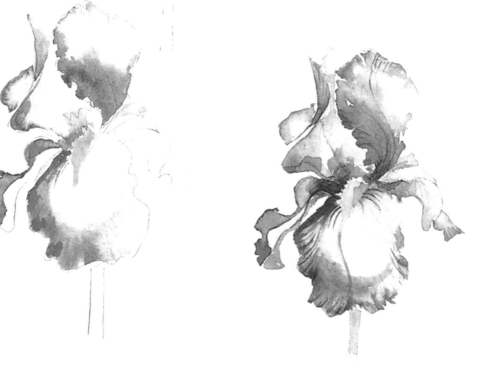

Morning glory *(Trumpet)*

1 Dampen each petal. Paint an ultramarine wash, leaving the flower centre white. Add a little dioxazine violet to the upper petals.

2 Paint a second wash using a strong mix of ultramarine and dioxazine violet, darkening the paint toward the edges.

3 Mask the stigma and paint the flower centre with Indian yellow, then remove the masking fluid.

4 Use a stronger ultramarine and violet mix to indicate petal flow and uneven edges.

5 Paint two washes of sap green for the leaves and add dioxazine violet for the winding stems.

Bluebell *(Trumpet)*

1 Paint the shapes of the flowers with a mix of ultramarine and permanent rose. As it dries, add more ultramarine to the shadowed side.

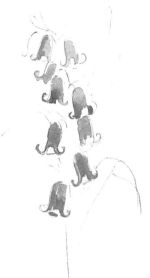

2 Add definition with a deeper mix and paint the undersides of the flowers with a pinker mix.

3 Add the leaves using several washes of sap green.

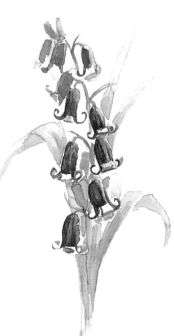

Love-in-the-mist (Ray)

1 Paint a pale wash of cerulean blue onto the flower, reserving the white ridges. Add lemon yellow and paint the curling anthers.

2 Paint the darker petals with a mix of cerulean blue and ultramarine.

3 Mix ultramarine with indigo for the dark centre, leaving white dots for the stamens.

4 Paint the feathers and stem with a cobalt blue and lemon yellow mix.

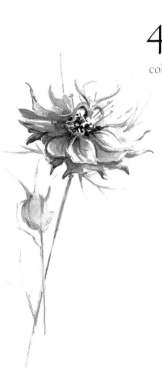

Campanula (Lipped and bearded)

1 Mask out the three-pronged styles, then flood the back petals with cobalt blue, tipping the paper so that it pools at the centre. Paint the nearer petals in a lighter tone, leaving a tiny edge of white.

2 Add dioxazine violet to the blue and paint into the dark centres, pulling the paint into the petal ridges.

3 Build up the centres with small brushstrokes of dark dioxazine violet. Rub off the masking fluid and tint the styles with lemon yellow.

4 Paint the leaves, stem and bud with mixtures of sap green, ultramarine and lemon yellow, then glaze over the bud with violet.

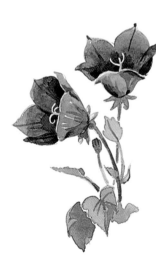

Hydrangea *(Multiheaded)*

1 Paint a loose wash using a mix of ultramarine and rose madder for the upper petals and phthalo blue for the shadowed parts. Drop in lemon yellow as the paint dries.

2 Paint a second wash, giving definition to the deep-set areas and particular petals.

3 Using the same colours, build up a mass of flowerets.

4 Mix lemon yellow and phthalo blue for the stem and leaves.

Delphinium *(Spike)*

1 Dampen the flower shapes and drop in a cobalt violet, ultramarine, phthalo blue, and dioxazine violet, letting the colours blend slightly. Drop in more colours as the paints dry.

2 Use stronger paint and a fine brush to build up the flower shapes, retaining the haze of blues.

3 Use sap green for the stem and leaves.

Lungwort (Trumpet)

1 Paint the flower shapes with a mix of ultramarine and permanent mauve, dropping in more ultramarine on the shaded side as the paint dries.

2 When dry, lift out the styles with a fine, damp brush. Tint with Naples yellow.

3 Add shadows to the flowers with dioxazine violet, using two tones for the buds. Use two tones of sap green for the calyxes.

4 Add indigo to the flower centres for depth. Add dark details to the buds and calyxes.

5 Paint each spotted leaf in turn, starting with mid-tones washes of sap green and olive green and quickly lifting out colour with a tissue wrapped around the end of a brush. When dry, add darker details with olive green.

Bachelor's buttons (Ray)

1 Mask the stamens and flood the petal shapes with ultramarine. Lift out paint from the upper petals as it dries.

2 Build up the centre with cobalt violet, adding alizarin crimson stamens.

3 Remove the masking fluid. Emphasize the flowerets using a strong ultramarine.

4 Use a cobalt green and lemon yellow mix for the stems and leaves.

Sea holly (Ray)

1 Begin by masking the tiny flowers in the centre. Starting at the top, paint the spiny bracts in pale cobalt blue, adding dioxazine violet toward the lower bracts.

2 Add a mix of ultramarine and phthalo green to the bract bases. Glaze the lower bracts with olive green. Paint the flower top with cobalt green and the bottom with permanent mauve.

3 Pick out the spines with a mix of live green and mauve. Use this mix for the stem. Paint the flower head with pale indigo on the shaded side, and dab stronger indigo into the bracts.

4 Rub off the masking fluid and tint the central row of flowers with ultramarine.

Grape hyacinth (Spike)

1 Using a fine brush, paint the tiny bells with cobalt blue, using a deeper mix on the shaded sides and reserving small highlights on the buds. While wet, dot in permanent rose on the top edge of the flowers and let it blend.

2 Paint the stalk with green-gold, darkening it with cobalt blue and olive green at the top. Paint the second spike in two tones of cobalt blue.

3 Paint the small negative shapes of background bells with ultramarine, dotting some of the centres with indigo.

4 Strengthen the stalk's centre with a phthalo green and olive green mix. Paint the back leaf and stalk with sap green, washing green-gold over the nearer ones. Shade with the phthalo and olive green mix.

The purple garden

▲ **Lucy Arnold** *Violet Jade Gems*

These orchid blossoms were painted from a half-barrel in the artist's yard. Painting each day at the same time gave Arnold consistency of lighting as she worked wet-in-wet within each flower and leaf, with the background as a final step. The artist wetted each negative space before loosely applying the colours.

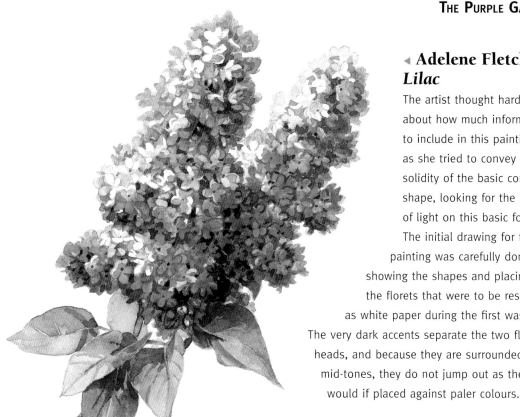

◄ Adelene Fletcher
Lilac

The artist thought hard about how much information to include in this painting, as she tried to convey the solidity of the basic cone shape, looking for the play of light on this basic form. The initial drawing for this painting was carefully done, showing the shapes and placing of the florets that were to be reserved as white paper during the first wash. The very dark accents separate the two flower heads, and because they are surrounded by mid-tones, they do not jump out as they would if placed against paler colours.

► **Jean Hanamoto**
African Violets

This composition is centred, but the negative space and random shapes are interesting enough to pull the eye away from the middle. A hard-edge technique has been used to define crisp separations of colour.

► Tracy Hall *Columbine*

A busy plant can be simplified by carefully selecting overlapping stems, and retaining their distorted shapes. The delicate details of leaves and flowers are faithfully recorded in the initial drawing, which was worked on a separate sheet and transferred when complete to protect the fragile surface of the paper.

► Jana Bouc *Bearded Iris*

One interesting thing about this painting is that it demonstrates how, contrary to common belief, watercolours can be changed and corrected. Originally, the background was a white wall and a window with a green trim, which was not successful. Then the artist tried a rich brick red background colour and finally this mottled maroon colour which complements the sense of light shining through the delicate petals of the iris.

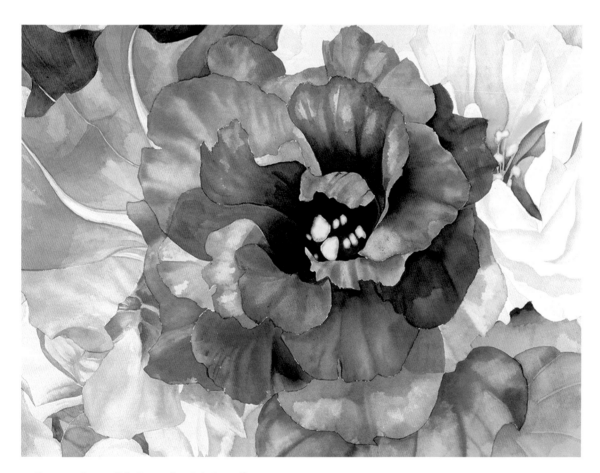

▲ Lucy Arnold *Purple Lisianthus*

The flowers for this watercolour were placed in water and painted in the studio. After sketching in the overall design very lightly in pencil, each petal was painted separately using a wet-in-wet technique. The close-up view emphasizes the lush, intense colour and sculptural depth of the purple flower.

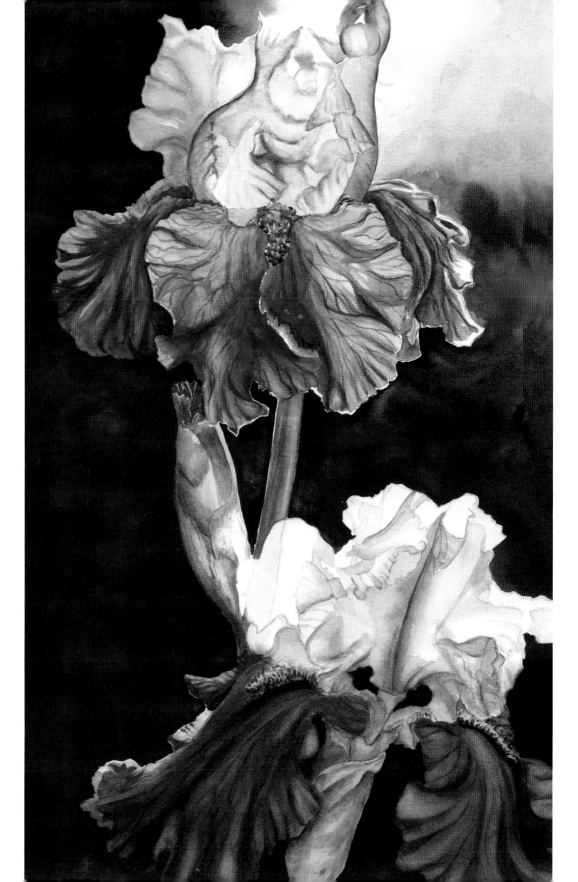

Clematis colours

lemon
yellow

green-gold

permanent
magenta

phthalo
blue

dioxazine
violet

permanent
mauve

olive
green

1 Mask out the central boss of stamens. Paint the petals with permanent mauve, darkening the top two and reserving lines of white for the petal ridges. While damp, use a fine brush and permanent magenta to paint the centre ridges of the petals.

2 Darken the ridges on the top petals with touches of dioxazine violet. When dry, rub off the masking fluid.

3 Paint the stamens with lemon yellow, adding detail with permanent mauve.

4 Paint the leaves and stem with mixes of green-gold and phthalo blue, darkening with olive green. Glaze thin permanent magenta over the stem and bud.

Columbine (*Trumpet*)

1 Mask off the stamens. Lay a light variegated wash over the petals in permanent mauve and permanent magenta, adding ultramarine for the shadowed areas.

2 Paint the trumpet in stronger permanent mauve, and use a lighter mix to establish ridges and shadows on the petals that form the frill.

3 With dioxazine violet, paint linear details on the trumpet to give it form, lifting out a vertical highlight by wetting with a fine brush and then blotting out. Paint the back spurs in shades of ultramarine, and add details on the frill petals with mid-toned violet.

4 Rub off the masking fluid and tint the stamens with green-gold and quinacridone gold.

Lavender (*Spike*)

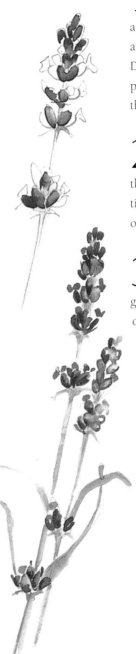

1 Paint each floweret separately using a mix of ultramarine and permanent mauve. Drop water in to push the colour into the hard edges.

2 Add further flowerets in the same way, with tiny mauve flowers on some.

3 Use a mixture of lemon yellow, sap green and cobalt green on the stem and leaves.

155

Allium colours

cadmium
yellow

permanent
mauve

cobalt violet

dioxazine violet

sap green

olive green

burnt sienna

Allium *(Pompom)*

1 Mask off some of the nearest spidery star shapes, then use a fine brush and a fairly dry permanent mauve and cobalt violet mix to paint a network of fine lines radiating out from the floret centres.

2 Using a darker mix of the same colours, plus small touches of burnt sienna, build up more star shapes, concentrating colour in the centre of the sphere shape.

3 Weave olive green into the centre. Add strong permanent mauve to build depth. Remove the masking fluid and paint the star centres in cadmium yellow, emphasizing with dioxazine violet.

4 Paint the stem in sap green, with olive green for the shadow.

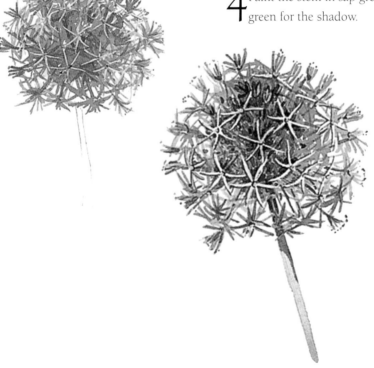

Black parrot tulip *(Cup and bowl)*

1 Paint each petal separately, starting with the two at the front. Wet the paper and lay on a mix of permanent mauve, permanent magenta, and a touch of indigo, tipping the paper so that the paint pools at the bottom. While the wash is still damp, suggest some ridges following the forms of the petal.

2 For the back petals, add ultramarine to the mix, leaving a little white paper showing to mark the division.

3 Build up the near petals with a stronger mix of the first colours, using more mauve. Paint dark shapes between the petals.

4 Finish the back petals with tones of dioxazine violet, darkest where the front and back petals meet. Emphasize the nearest dark details with permanent mauve and indigo.

5 Use sap green for the stem, touching the top with magenta.

Aster *(Simple star)*

1 Paint each petal with a diluted mix of cobalt violet and ultramarine, allowing it to pool at the tip of each petal.

2 Pick out the back petals and shadowed areas in a stronger mix. Paint the flower centres in lemon yellow, with cadmium yellow dropped in as it dries.

3 Add more ultramarine and pick out deeper shadows and tiny triangle shapes around the yellow dome. Drop wet dots of brown-pink into its darker side.

Passionflower colours

lemon yellow

permanent rose

alizarin crimson

cobalt blue

sap green

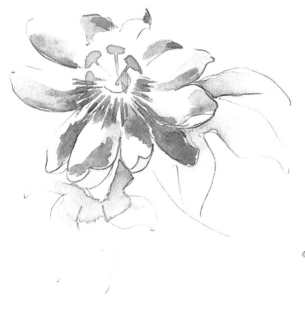

Passionflower (Ray)

1 Wash a soft mix of cobalt blue and permanent rose into the darker areas of the petals, and a pinker mix into the lighter areas. Paint the stamens in strong lemon yellow with touches of sap green.

2 Use the pinker mix again for the rays, then work the darkest areas with a stronger mix. Use lemon yellow and sap green to start the leaves.

3 Add the fine details in lemon yellow, strong permanent rose and alizarin crimson. Mix these colours and add a touch of the mix to the edges of the leaves, prior to a loose wash of lemon yellow and sap green.

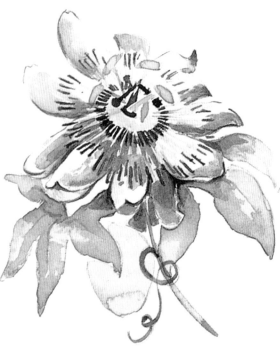

Fleabane (Ray)

1 Mask off the stamens surrounding the centres, then paint the front flower with the crisp strokes of a fine brush, using a mix of permanent magenta and ultramarine.

2 Paint the back flower in the same way but with more ultramarine added to the mix. Wash in lemon yellow for the centres, adding green-gold as it begins to dry.

3 Using a strong magenta and ultramarine mix, pick out the top and bottom petals in the foreground flower. Build the back flower in a paler tone.

4 Rub off the masking fluid and tint the stamens with cadmium yellow. Use a mixture of sap green and olive green for the leaves and stems.

Buddleia (Ray)

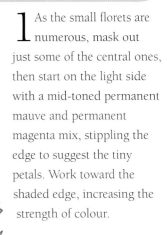

1 As the small florets are numerous, mask out just some of the central ones, then start on the light side with a mid-toned permanent mauve and permanent magenta mix, stippling the edge to suggest the tiny petals. Work toward the shaded edge, increasing the strength of colour.

2 Build up the cone shape by painting darker details on the shaded side. Add more mauve to the mix using the tip of a well-loaded brush. When dry, rub off the masking fluid.

3 Tint the white shapes with cobalt violet and permanent rose, and dot in the centres with brown madder and permanent rose.

4 Paint the leaves with a mixture of green gold and phthalo blue, with a dark ultramarine shadow beneath the flower.

Lilac colours

green-gold

permanent rose

ultramarine

indigo

permanent mauve

cobalt violet

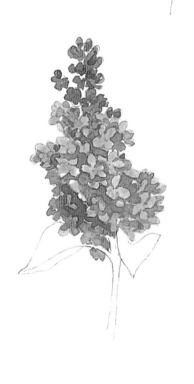

Lilac *(Multiheaded)*

1 Paint some of the nearer open florets with cobalt violet, then add permanent mauve for the top buds and the shaded florets at the bottom.

2 Paint around the light-coloured central florets with permanent mauve to make them stand out.

3 Continue to build up, outlining some of the florets on both sides with a permanent rose and ultramarine mix, adding accents of indigo and permanent mauve on the shaded side. Use the same mix to dot in some centres.

4 Paint the leaves and stem with mixes of green-gold and ultramarine.

Hyacinth (Multiheaded)

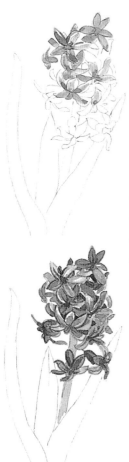

1 Paint the florets with a dryish mixture of permanent mauve and ultramarine. When dry, glaze a thin wash of permanent rose on the lighter side.

2 Paint in some shapes behind the front florets with a mid-toned mauve, then add ultramarine and darken those on the shaded side. Use a fine brush to outline the more prominent florets in mauve.

3 Using dioxazine violet, dot in the centres and build up small areas of dark behind the florets and on the shaded side.

4 Paint the strap leaves and stalk with a mix of sap green, cobalt blue, and olive green, using a higher proportion of blue for the back leaf.

5 Paint two washes of sap green for the leaves and add dioxazine violet for the winding stems.

Pansy (Lipped and bearded)

1 Reserving white paper for the yellow apron, drop in fairly wet dioxazine violet. Mix it with a touch of ultramarine for the front petal.

2 Work stronger paint into the petals, and add a mix of ultramarine and permanent rose for the top petals.

3 Using a fine brush and dry paint, fill in the central shape with cadmium yellow and strong dioxazine violet.

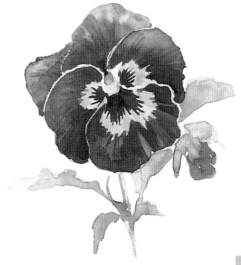

Anemone *(Cup and bowl)*

1 Pick out each petal in a wash of permanent magenta and ultramarine. Use water to push the colour away from the white areas.

2 Add more ultramarine and work the darker areas, reserving a fine line around each petal to highlight the slightly shaggy edge.

3 Pick out the petal ridges with drier paint. Apply layers of a permanent magenta and ultramarine mix to the underside of the petals, and drop indigo into the darkest parts.

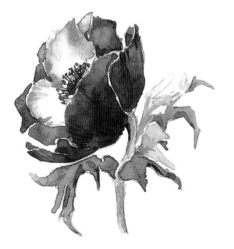

Violet *(Lipped and bearded)*

1 Wash a mixture of permanent mauve and cobalt blue over the petals, reserving small patches of white.

2 Build up the forms with a permanent mauve and ultramarine mix, adding wavy petal lines. Paint the opening bud with a pale wash of those colours.

3 Complete the main flower with dark dioxazine violet. Paint the centre with quinacridone gold. Add detail on the other flower using mid-toned violet, with some permanent magenta for the back spur.

4 For the leaf, use a wash of green-gold and cobalt blue, and for the stems and spur leaves switch to sap green darkened with olive green.

Peach-leaved bellflower *(Bell)*

1 Mask off the stamens. When dry, paint the bells with a mix of permanent mauve and permanent magenta.

2 While wet, dab ultramarine into the centres. Paint the stalk and leaves with a green-gold and cobalt blue mix, and lay a light violet over the bud.

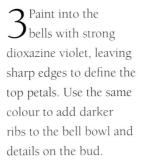

3 Paint into the bells with strong dioxazine violet, leaving sharp edges to define the top petals. Use the same colour to add darker ribs to the bell bowl and details on the bud.

4 Build up dark shadows on the stalk and leaves with a mix of sap green and olive green.

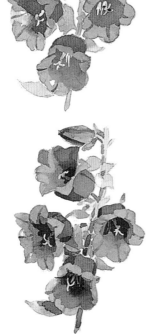

Fritillary *(Bell)*

1 Build the basic bell shape with a delicate wash of alizarin crimson and ultramarine, reserving white areas of patterning.

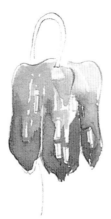

2 Overlay washes of the same colour with cadmium red to vary the colour and create depth.

3 Build up the shape and pattern using mixes of the three colours and add details with dry paint and a fine brush.

4 Colour the leaves and stem with a wash of cobalt blue and sap green.

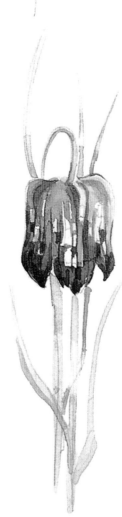

Thistle *(Multiheaded)*

1 Dot masking fluid on the flower head to create highlights, then wash cobalt violet over the whole shape. Add more as it dries, along with touches of permanent mauve.

2 Create the shadows with strong dioxazine violet and allow them to flow into the bulbous shape below.

3 Rub off the masking fluid and use a very fine brush to paint the spike with strong dioxazine violet.

4 Use the very fine brush to paint the prickles in the cobalt green foliage.

Hibiscus *(Simple star)*

1 Mask the stamens and top anthers with small dots, then wash a permanent mauve and cobalt blue mix onto the back petals, reserving areas of white. For the front petals add permanent rose to the mix.

2 Strengthen the first washes and build up the shadows, then paint the bud with a mix of green-gold and cobalt blue.

3 Paint the blotches at the bases of the petals with strong magenta. Add dark indigo details when nearly dry. Tint the centre with pale raw sienna then remove the masking fluid.

4 Paint the back leaves with mixes of green-gold and cobalt blue, adding mauve where they meet the flowers. Finish the bud with darker sap green.

Petunia *(Trumpet)*

1 Paint each area with a loose wash of permanent mauve, leaving the upper areas almost white and adding the faintest touch of lemon yellow. Work dioxazine violet into the shadows as the first wash dries.

2 Shape the ruffled petals with deeper washes and patches of mauve and violet.

3 Add ultramarine to the mix to pick out the deep trumpet and the veins of the petals.

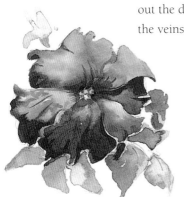

Michaelmas daisy *(Ray)*

1 Dot masking fluid in the stamens around the central boss. Paint the left-hand flower with strong strokes radiating from the centre, using a mix of permanent mauve and cobalt violet.

2 Paint the right-hand flower with violet, and those in the background with a paler mix of violet and ultramarine. Build up darker tones on the front flowers with a wash. Paint the centres with cadmium yellow.

3 Add more shadows using permanent mauve with dioxazine violet at the centres. Remove the masking fluid and tint the stamens with cadmium yellow. Glaze a shadow on the centres with thin mauve.

The white garden

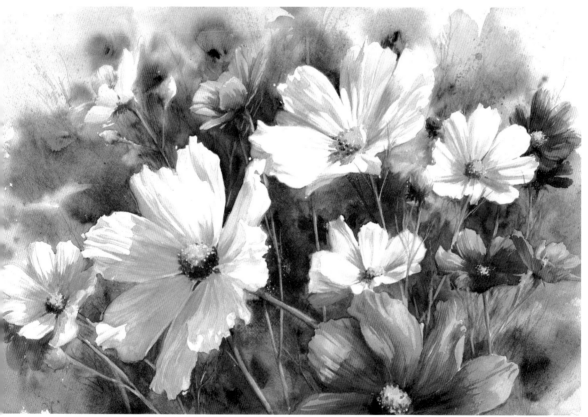

▲ Jennifer Bowman *Cosmos*

This painting is a study in creating whites – lots of them. Cool skies create cool highlights; reflected light from foliage makes for green reflections; the yellow centres cast golden highlights back onto the cool shaded sides of the petals in shadow. Wetting out the paper all around the flowers allowed the artist to charge in many colours loosely, creating suggestions of other flowers in the background without laboring over details.

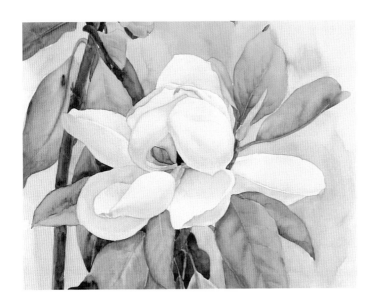

◄ **Elena Roché**
Magnolia Number 2

To achieve the clean white effect of the magnolia flower, the artist washed in shadows with diluted winsor blue and cadmium lemon.

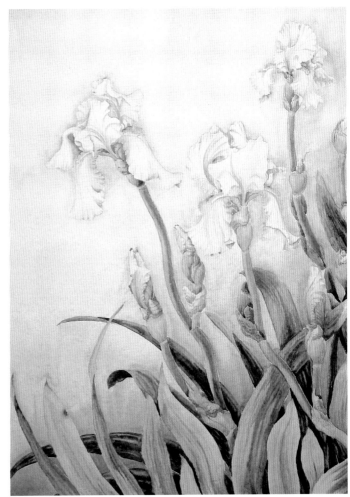

► **Elena Roché**
White Irises

In order to help the white flowers come forward, the artist has lightly washed the background with colours similar to those used in the painting.

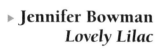

◄ Jane Pelland
Calla Lily

Layered washes of transparent watercolour build from light to dark, while the fine details of leaf and flower veins have been created with a dry brush. The artist was initially attracted to the shape of the plant, and has successfully captured the contrast of the creamy calyxes against the lush green foliage.

► Jennifer Bowman
Lovely Lilac

This painting used a 'yin–yang' methodology, with two very different approaches. The artist washed in large areas of light purples, pinks and greens in the background to hold the overall image together. This wet-in-wet technique is a great way to get the general feel for a painting, and it is complemented by the very different treatment of the foreground. She then painted the cascades of flowers in a slow, layered, glazing method.

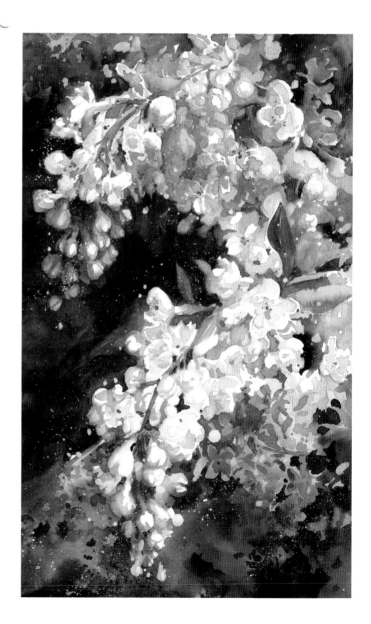

▲ Nancy Meadows Taylor *Casablanca*

Inspiration for this painting came from a regal lily in the National Botanical Garden in Washington, DC. The frontal view of the composition presents a sense of elegance and power, while the placement of the coneflowers to the right balances the centre flower – their warm colours lead the eye through the painting.

Heather colours

Naples yellow

lemon yellow

cobalt blue

indigo

phthalo green

olive green

sap green

burnt sienna

Heather *(Spike)*

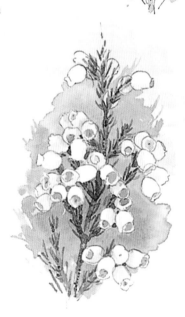

1 Lightly touch the lower bells with Naples yellow before placing a background wash around the shapes. Paint wet-in-wet, starting with lemon yellow and gradually adding phthalo green and cobalt blue. Use the same colours to paint the throats and shadows of the bells.

2 Paint the twig with a burnt sienna and olive green mix, varying the tone by dabbing with a tissue in places. Touch in the spiky leaflets with sap green.

3 Emphasize the twig and floret centres with specks of dark indigo. Outline some florets using mid-toned indigo.

Water lily *(Cup and bowl)*

1 For the shadow of the upper petals use cobalt blue, adding a trace of brown-pink. Use a deeper mixture for the lower petals.

2 Paint deeper shadows in cobalt blue and stamens in lemon yellow and Indian yellow.

3 Use an Indian yellow and sap green wash on the leaves.

4 Use stronger mixes of flower and leaf colours to build up depth and colour, and fine brushwork for stamens and deepest crevices.

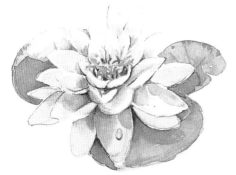

Snowdrop *(Bell)*

1 Use an ultramarine background wash to define each flower shape. Push the colour towards the edges to sharpen some outlines.

2 Paint a wash of phthalo blue and lemon yellow to make a block of leaf shapes. Use the same, darker wash for the lower stems.

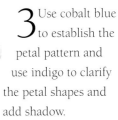

3 Use cobalt blue to establish the petal pattern and use indigo to clarify the petal shapes and add shadow.

4 Paint the flower stems and sepals with a mix of cobalt blue and lemon yellow, and use ultramarine and lemon yellow to clarify the leaf shapes.

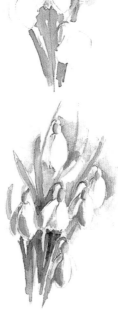

quinacridone
gold

green-gold

raw sienna

cobalt blue

ultramarine

indigo

sap green

olive green

burnt umber

brown madder

Prunus blossom *(Multiheaded)*

1 Wash around the upper petals with pale ultramarine. Paint the petal shadows with a raw sienna and cobalt blue mix, leaving dots of white. Darken the mix as you reach the lower petals.

2 Deepen the shadows using the same colours, but with more blue. Lay a wash of quinacridone gold and green-gold on the foliage, varying the tones.

3 Tint the buds and small leaves behind the flowers with sap green.

4 Build up the shadows in the deepest crevices with touches of indigo. Add some stamens in indigo and brown madder.

5 To give the leaves form, paint in veins with a strong burnt umber and olive green mix.

Apple blossom *(Simple star)*

1 Use a loose wash of cadmium yellow and sap green for the blossom outlines. Paint patches of diluted permanent rose for middle-toned petal areas, reserving large areas of white.

2 Paint a darker wash on the leaves, blending some of the green paint into the pink for shadows.

3 Add cadmium yellow to the centre. Mix permanent rose and sap green for the stem. With a fine brush, build up layers of paint on the petals.

Rose *(Cup and bowl)*

1 Paint a wash of Naples yellow and lemon yellow onto the petals, reserving white highlights. Surround the flower with a wash of sap green and rose doré.

2 Paint the darker areas of the petals using Naples yellow and lemon yellow, and the petal shadows with cobalt blue.

3 For the stem and deepest shadows, use rose doré and sap green.

Wood anemone colours

quinacridone gold

cadmium yellow

green-gold

cobalt blue

permanent mauve

phthalo green

olive green

sap green

Wood anemone *(Simple star)*

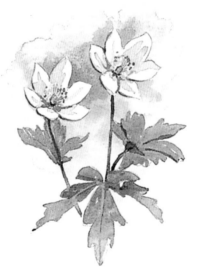

1 Outline the petals with a variegated wash of green-gold and cobalt blue, overlaying the leaves in places. Paint the stamens in cadmium yellow.

2 Treat the leaves loosely, with mixtures of green-gold, phthalo green and quinacridone gold applied wetly enough to form pools. Make the colour bluer as the leaves recede.

3 Paint the petal shadows with pale permanent mauve, leaving white highlights. Build up the flower with touches of a strong mauve and cobalt blue mix, then paint the central dome with sap green.

4 Add darker details to the leaves with olive green and phthalo green, and wash over the stem with mauve to give a pinkish tinge.

Frangipani *(Trumpet)*

1 Paint a light lemon yellow wash on the petals, leaving plenty of white. Use strong Indian yellow for the flower centres.

2 Establish the flower shape with a wash of lemon yellow and sap green for the leaves. Use pale cobalt blue for the shadows and dioxazine violet for deeper shadows.

3 Work into the leaves with darker sap green. Sharpen the flower centre and underside of the stems with brown-pink, emphasizing the swirling character of the blooms.

Lily *(Trumpet)*

1 Outline the flower with a mix of Naples yellow and cobalt blue, then paint the flower shadows with cobalt blue.

2 Use permanent rose for the ridges on the trumpet and the underside of the petals. Add touches of rose and cobalt for the petal ridges and frills, then use strong lemon yellow for the flower centre.

3 Paint Indian yellow anthers and emphasize the stamens with a mix of Indian yellow and cobalt blue.

Honeysuckle colours

Naples yellow

lemon yellow

cadmium yellow

quinacridone gold

raw umber

phthalo blue

olive green

sap green

cobalt green

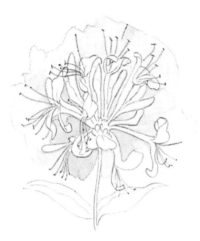

Honeysuckle *(Lipped and bearded)*

1 Mask out all the stamens. Paint a wash of phthalo blue around the cluster and let dry. Tint the buds with a mix of sap green and Naples yellow. Paint the tubes with diluted Naples yellow and lemon yellow, reserving highlights.

2 Drop cadmium yellow into the flower's throats and darken the turned petals with Naples yellow and sap green. Paint the central small buds and leaves with darker sap green.

3 Build up the flowers with a raw umber and Naples yellow mix, then define the central buds and leaves with sap green and olive green. Rub off the masking fluid and paint the anthers with quinacridone gold.

4 Paint the large leaves and stem with cobalt green and sap green, darkening with olive green.

Daisy *(Trumpet)*

1 Paint a variegated wash of ultramarine around the flower.

2 For the shadows on the petals, use cobalt blue, dropping in some Indian yellow. For the back petals and deep shadows use ultramarine with traces of alizarin crimson.

3 Use lemon yellow for the dome, moisten it and build the shadowed side with drops of Indian yellow and brown-pink. Pick out the crevices with ultramarine.

Peony *(Cup and bowl)*

1 Mask out the central stamens and lay a pale olive green background wash. Paint the petals with a wash of Naples yellow, reserving the highlights. Add lemon yellow to the flower's centre and feather the paint outward.

2 For the shadows on the petals, start with a mix of cobalt blue and cobalt green, then darken it by adding quinacridone gold and more blue.

3 Paint the central star with a dioxazine violet and permanent magenta mix, varying the tones. Remove the masking fluid and tint the stamens with cadmium yellow and burnt sienna.

4 Paint the leaves mainly wet-in-wet, using mixtures of cobalt green, cobalt blue and green-gold, adding indigo for shadow.

Shasta daisy colours

cadmium
yellow

cadmium
orange

permanent
magenta

ultramarine

dioxazine
violet

phthalo green

olive green

Shasta daisy *(Ray)*

1 Paint a light wash of ultramarine around the light-catching top petals. Work the centres of the flowers with short brushstrokes of cadmium yellow, fading the colour outward by progressively watering it.

2 Paint the petal shadows with a pale mix of permanent magenta and ultramarine, leaving most upper petals white. Using a fine brush, outline the central smaller petals.

3 Strengthen the shadowed petals with ultramarine, then partially outline them with a strong mix of ultramarine and dioxazine violet. Drop cadmium orange into the centres, and strengthen with dioxazine violet.

4 Paint the stems and leaves with phthalo green and olive green.

Calla lily *(Trumpet)*

1 Establish the flower outline with a wash of cadmium yellow and sap green, pushing it toward the edges. Paint the inside of the trumpet with a mix of cobalt blue and sap green, tipping the paper so that the paint pools in the deepest shadow areas.

2 Add touches of indigo for the underside of the petals and use strong cadmium yellow for the stamen.

Calla lily colours

cadmium yellow

cobalt blue

indigo

sap green

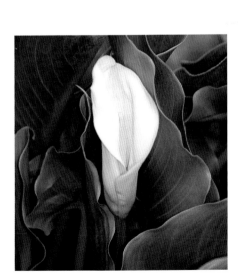

The calla lily produces large, showy flowers with bright bracts.

Berries and Leaves

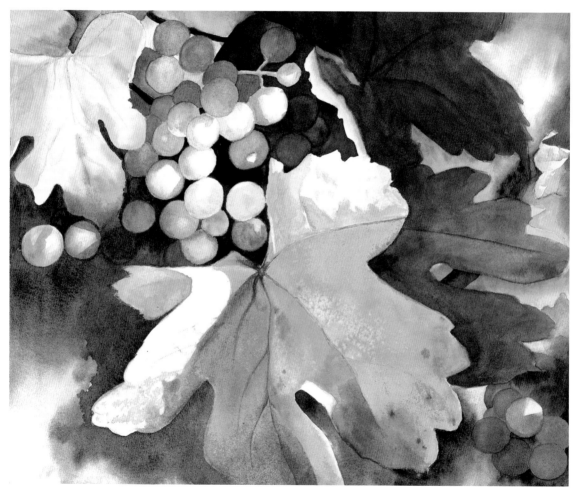

▲ **Maud Durland** *Vineyard Tapestry*

This painting uses a very limited palette – just yellow, blue and red – which the artist used on their own and mixed in different proportions. She added salt to the big leaf while it was still wet.

◄ Lucy Arnold
Japanese Maple Leaves

The autumn colours of these Japanese maple leaves have been captured using a wet-in-wet technique. Reds, yellows and greens were dropped in and randomly floated, working on each leaf individually. The effect is very realistic.

► Elena Roché
Apricots

Branches bending under the weight of ripening apricots give this painting its diagonal composition. The background, painted wet-in-wet with light colours, gives a summery feel.

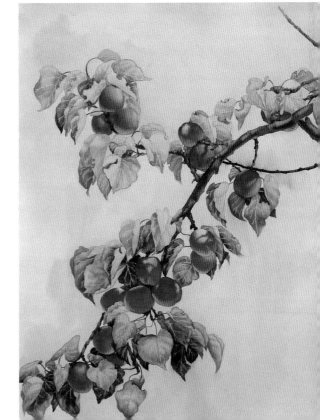

Mahonia colours

green-gold

raw umber

permanent
mauve

dioxazine
violet

cobalt blue

indigo

phthalo green

cobalt green

burnt umber

Mahonia

1 Mask out some of the tiny twiglets in the centres of the bunches. Paint the nearest berries with a mix of cobalt blue and phthalo green, dropping in a little green-gold wet-in-wet. For the other berries, use mixes of cobalt blue and dioxazine violet, reserving small white lines to separate them.

2 Build up the forms with dioxazine violet on the nearer berries and a violet and permanent mauve mix on the background ones, softening the edges while still damp. Paint in the stem with raw umber.

3 Continue to build up, using stronger mixes of the same colours. Use indigo for the deepest shadows and the berry tips.

4 Paint the leaves loosely with mixes of cobalt green, phthalo green and cobalt blue, then darken the main branch with burnt umber. Remove the masking fluid and tint the twiglets with raw umber.

Snowberry

Snowberry colours

Naples yellow

cobalt blue

phthalo green

olive green

burnt sienna

burnt umber

brown madder

1 Outline the berries on the light side with a variegated wash of cobalt blue and phthalo green. Paint the shaded sides of the berries with Naples yellow, adding burnt umber toward the shaded side, leaving less white.

2 With weak cobalt blue, paint shadows on each berry, darkening with the blue and burnt sienna on the shaded side.

3 Dot in berry tips with brown madder, and use the same colour to outline some of the berries. For more emphasis, darken the small crevices with cobalt blue and burnt sienna.

4 Use brown madder for the twigs, and olive green and phthalo green mixes for the leaves.

Cotoneaster colours

lemon yellow

Indian yellow

cadmium
orange

permanent
mauve

indigo

phthalo green

sap green

burnt sienna

burnt umber

brown madder

Cotoneaster

1 Using the tip of a fine brush, circle the nearer berries with burnt sienna mixed with brown madder, reserving highlights. While the paint is still wet, add some dots of cadmium orange. For the more distant berries, mix permanent mauve with the red.

2 Paint the leaves with a mixture of sap green, lemon yellow and phthalo green. Add the twigs using burnt umber mixed with Indian yellow.

3 Fill in some background berries with strong crimson and paler crimson, outlining a few of the nearer berries for emphasis. Dot in the berry tips with indigo.

4 Darken the twigs' shadows with burnt umber. Add detail to the leaves using sap green and phthalo green and paint simple shapes for the back leaves using phthalo green.

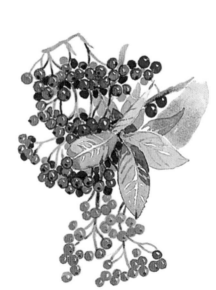

Firethorn

1 Start with the nearest berries, painting them with Indian yellow and reserving a small highlight on each one. Paint those farther away with cadmium orange, but do not highlight.

2 Using a mix of cadmium orange and burnt sienna, build up the forms of the nearer berries. Soften the edges immediately with a damp brush. Mix in brown madder for the back berries.

3 Paint the leaves using sap green, lemon yellow and phthalo green mixes. Paint the branches using burnt sienna and phthalo green.

4 Strengthen the tones on both leaves and berries using stronger mixes of the previous colours, but with indigo added for the leaves. Dot in the tips of the berries with burnt umber.

5 Using a permanent mauve and burnt umber mix, paint the thin twigs and add darker touches to the branch.

Firethorn colours

lemon yellow

Indian yellow

cadmium orange

permanent mauve

indigo

phthalo green

sap green

burnt sienna

burnt umber

brown madder

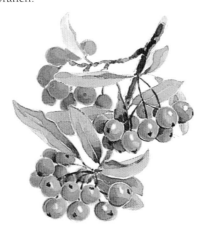

Primula

1 Paint a loose wash of cobalt green around the veins, then darken a little on the shaded side with sap green. When dry, glaze on some lemon yellow, leaving white highlights.

2 Paint in details around the veins with a mid-toned sap green, concentrating most of the colour on the shaded side.

3 Continue to build up the dark shadows with an indigo and sap green mix, using the tip of the brush and making short, calligraphic strokes.

4 To anchor the plant, suggest the soil beneath it with a wash of raw umber and burnt umber.

Fern

1 Start at the top of the leaf with sap green, keeping the paint very fluid. As you work down the leaf, add olive green first, then add phthalo green toward the bottom.

2 While still wet, drop in watery green-gold on the tip and allow it to run down a little. Lift out the central spine with a dry pointed brush.

3 Paint in the spine with burnt umber, leaving a soft line of white, then take the colour out to the leaflets.

Tulip

1 Mix lemon yellow and cobalt green and paint the top sides of the leaves and the stem, reserving white highlights. Add more cobalt green for the undersides of the leaves.

2 Deepen the shadows on the undersides with more cobalt green and a touch of sap green, leaving the central vein as a highlight. Soften the edges with a damp brush as you work.

3 Paint around the main veins on the leaf tops using sap green and a little cobalt green.

4 Paint in the darkest details with indigo added to the two greens, again softening the edges where needed with a damp brush.

Chrysanthemum

1 Paint the top leaf using a sap green and indigo mix and a well-loaded brush, alternating the pressure to give tonal variation. When dry, lay a thin glaze of green-gold down the centre.

2 Paint around the veins on the top leaf with a stronger mix of the original colours. Paint the main stem and the underside of the lower leaf with cobalt green, adding sap green for the upper part, and darkening the colour on the near edge.

3 Using the indigo/sap green mix again, but this time with a higher proportion of indigo, put in the dark shadows on the top leaf.

Poppy

1 Paint a light wash of lemon yellow. As it dries, add a lemon yellow and cobalt green mix.

2 Build up the leaves with patches of cobalt green. Add cobalt blue for darker touches, emphasizing the leaf edges with a fine brush.

Geranium

1 Paint a wash of cadmium yellow mixed with cobalt blue. Touch in a scalloped edge with cadmium red.

2 Add phthalo blue to the mix and paint a variegated wash.

3 Add cadmium red and stipple in the patterning with a stiff brush.

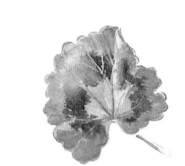

Rose

1 Paint the leaves with varied washes of cadmium yellow and cobalt blue, using more yellow where they catch the light.

2 Paint around the veins on the nearer leaves with sap green, concentrating most colour in the shaded areas. Add cobalt blue and paint the shadows and veins on the background leaves.

3 Build up the forms of the nearer leaves with a sap green and olive green mix, varying the tones. Use the same mix for the stem, then add cobalt blue.

4 Put in touches of detail on the background leaves before painting the thorns in brown madder.

Ivy

1 Begin by painting a wash of lemon yellow.

2 Use sap green for a second wash, omitting the leaf ribs.

3 Add phthalo blue and a touch of ultramarine to the mix and paint the darker patches, blending the paint with a dry brush.

Index

Credits

Quarto would like to thank the following artists, who are acknowledged beside their work:

LUCY ARNOLD
www.lucyarnold.com

JANA BOUC
www.janabouc.com

JENNIFER BOWMAN
www.jenniferbowman.com

LIBBY CARRECK

ROSALIND CUTHBERT

JANE LEYCESTER PAIGE

JOE FRANCIS DOWDEN
www.joedowden.com

MAUD DURLAND
www.maudart.com

ADELENE FLETCHER

RICHARD FRENCH
www.richardfrenchfineart.com

TRACY HALL
www.watercolour-artist.co.uk

JEAN HANAMOTO
www.garlic.com/~artworks/marijuana_art

LIZZIE HARPER
www.lizzieharper.co.uk

JUDY LINNELL

NANCY MEADOWS TAYLOR
www.nancymeadowstaylor.com

JANE PELLAND
www.janepelland.com

ELENA ROCHÉ
www.elenaroche.com

KAREN VERNON
www.karenvernon.com